The Art of Gambling

The Art of Gambling

Through the Ages

ARTHUR FLOWERS AND ANTHONY CURTIS

Foreword by LeRoy Neiman

HUNTINGTON PRESS • LAS VEGAS

Huntington Press
3687 South Procyon Avenue
Las Vegas, Nevada 89103
(702) 252-0655 Phone
(702) 252-0675 Fax

The Art of Gambling: Through the Ages
Copyright ©2000, Huntington Press

ISBN 0-929712-90-0

Printing History
1st Edition—January 2000

Interior Design: Jason Cox
Jacket Design: Bethany Coffey

Printed in China

Dedicated to
June, for her constant support and encouragement.
And to Sam and Lauren, for the future.

Acknowledgments

The authors are indebted to the score of talented and enthusiastic people who assisted in this complex project. Some made direct contributions, and we acknowledge them here.

Beginning with day one, we thank Deke Castleman, senior editor at Huntington Press, who endorsed the concept from the first time he saw the proposal, then lent his masterful editor's pen to the text. Jackie Joniec and Erik Joseph were also early supporters and helped in parts of the image-search process. In that capacity, the contributions of all the tireless reference librarians, especially Jim Lane, Maggie Slomka, and Verdell, whose cancer did not allow her to see the completion of the project, were integral—without the continuous whole-hearted assistance of these professionals, we would still be searching the library stacks.

Thanks are due Vanessa Giordano and Phillipe Juarez for helping us overcome a few language barriers, and especially Jessica Roe, for assistance in both translation and research.

Our unending gratitude extends to LeRoy Neiman for his unselfish support of the project and his many contributions contained herein, including the book's insightful Foreword. To LeRoy's Lynn, who continues to demonstrate her unbridled excitement for the book every time we see her; to Dave Hickey and Fred Sigman for their skillful teaching of Art History, which provided us with an enlightened understanding of the evolution of the art world; to the gamblers who contributed their expertise, Stanford Wong, Blair Rodman, Fred David, and Barry Meadow, among them, and to Bart Rakay for his good eye; thanks to all.

We would like to register particular gratitude to Suz Brna, for introducing us to other living artists whose fine works adorn these pages. And to Zara Kriegstein who was always there to help.

To HP staffers Katie Rose Joniec, Jim Karl, Toya Norwood, and Jody

Olson: our heartfelt appreciation for their help, even when they weren't directly involved in the project. Direct contributors from the Huntington Press staff were Michele Bardsley and Michael Toole, whose Internet skills saved countless hours in the search process. More appreciation to HP managing editor Lynne Loomis, whose exceedingly high standards are reflected in the final product. And exceptional thanks to two top HP executives, Bethany Coffey and Jason Cox, whose combined artistic and technical skills brought everything together. One more important thank you goes to Lauren Knight for assisting in the image-selection process; it was a special and unique treat for us.

Last, but certainly far from least, we are deeply indebted to the project's Acquisitions Editor, Len Cipkins. Len's three D's—diligence, dedication, and doggedness—made his pursuit of transparencies a remarkable success. His persistence was matched only by his tolerance of less-than cooperative employees of various public institutions. How many hang-ups, "no Ingles," and "don't bother me's" did he have to endure? Too many! Of the approximately 150 "must-have" images we charged Len with obtaining, he was 98% successful. Who says that a strong work ethic doesn't pay off? What a pro!

Introduction

Ever since we initiated this project approximately three years ago, most people with whom we raised the topic of "gambling art" responded with some variation of, "Do you mean the dogs playing poker?" Granted, we knew that there was more out there than the dogs, but our searches quickly revealed a mother lode of gambling images, the likes of which shocked us—fabulous works rendered by history's masters. Most people have heard of LeRoy Neiman and won't be surprised to learn that he's committed casino to canvas on a few occasions, but Cézanne, Picasso, Daumier, Goya, Van Gogh, and Caravaggio?

It's true that each of these great artists focused their talents, at some time, on the subject of gambling. But they represent only a small part of the artistic tour de force collected herein. To create *The Art of Gambling Through the Ages*, we identified more than 300 gambling-related paintings, drawings, etchings, and sculpture produced over a period of two and a half millennia. From these, the best 139 images, representing the work of 101 artists, were selected.

Since this volume's primary goal is to provide a source of visual-cognitive enjoyment, the images are displayed in full-page presentations whenever possible. Accompanying each is a facing page of text, which supplies a thumbnail sketch of the artist, then zeros in on the gambling itself. The intent is to whet the appetite sufficiently to send the reader back for a closer look, further enhancing the appreciation of these classic works.

In *The Art of Gambling Through the Ages*, we have not attempted to present art history in the traditional sense. Thus, we have ordered the images in a random, rather than a chronological, fashion. For those who wish to know more about the artists, their styles, or the various schools of art represented, we have supplied enough biographical data to provide a good starting point for extended study.

Formulating the gambling analysis presented a unique challenge that we didn't anticipate. The initial plan seemed simple. Since there were no Polaroids when the Romans played dice with knucklebones or the English gathered to gamble around cockfighting pits, we presumed we could trust that the artists preserved the scenes on canvas just as they'd witnessed them. But it quickly became evident that the artists (except for the Photorealists) often weren't worried about getting all the details right. At times we had to work with less than perfect information. On balance, however, the artists' renditions and the historians' accounts matched up remarkably well.

The reader will find the descriptions infused with a healthy dose of gambling jargon. In most instances, words, phrases, and concepts that are specific to gambling are placed within quotation marks. The names of the games are not capitalized, though they are italicized when they're a product of a language other than English. In anticipation of questions about whether all of the art depicts true gambling scenes, we'll concede that they all do not. However, we'll stand squarely behind the premise that if something *can* be gambled on, then at some time in the past it has been, and at some time in the future it will be again.

Finally, we'd like to acknowledge that a great deal of gambling art is not included in *The Art of Gambling Though the Ages*. Some pieces we were unable to locate. For a few, permissions could not be obtained. And surely there are many images that we still don't know about. All in all, though, we're confident that this volume contains the most exhaustive and prestigious body of artwork devoted to gambling ever assembled. How confident? We're laying 7-to-5.

Foreword *by LeRoy Neiman*

In 1957, the top man at the Fabulous Flamingo, Al Parvin, came to my Chicago studio and bought some horse race and bar paintings. It wasn't long after that I was flying to Las Vegas at his expense for a comped visit at his casino. There, he proceeded to woo me into painting a series of gambling scenes. That was the beginning—my virgin visit to Las Vegas and my introduction to the inner world of big-time gambling.

The subject wasn't completely new to me. I'd already done a number of gambling paintings of the tony world-class casinos of Deauville and Monte Carlo. But to tackle a frontier like Las Vegas, with its energy and openness, was going to be a whole new challenge. I'd have to dig deep.

The ambience was raw—remember, Caesars Palace had yet to be built. Themed fantasy hotels and casinos were years in the future. Las Vegas in the '50s was quite a contrast to the sophisticated, sedate, stiff Old World casinos where I had served my apprenticeship. Casinos on the Continent were so quiet that, all the way across the carpeted and chandeliered room, you could hear the ball bouncing on a spinning roulette wheel, along with the eerie chanting of the French croupier. Casinos in Las Vegas were so raucous that standing right at the roulette table, you could barely hear the dealer's call.

Though not a gambler myself, I got hooked on the gambling motif. I was not one of those kibitzers who circle a table in casinos and gawk like the galleries at a golf classic. Yet I had to get close for studying and observation, to check out the go-for-broke bettors of both sexes—their postures, passions, anxieties, and tensions.

Eventually I found myself downtown, observing the colorful high-stakes card players at Binion's Horseshoe's World Series of Poker. Once on the inside I could check the deceptive eye movements and body English of poker pros with sobriquets like Puggy, Tex, and Amarillo Slim.

Then it was on to examining the indulgences of the pampered high

rollers sipping Chateau Petrus '82, Lafite Rothschild '61, or Roederer Cristal while at play in the baccarat salon at the fabled Sands, Sinatra's house.

But mostly I gravitated to the center of the action—blackjack tables full of cowboys in 10-gallon Stetsons and stiletto-heeled kicky chicks tossing dice, the buzz of the crap tables serenaded by the shouts from the slots. Vegas was on a roll, and I got into it. This was my kind of town. The noisy casinos made for the noisy color in my paintings. That's how it all got rolling as a subject for me. From black-tied gamblers and croupiers swathed in European tradition to wild wide-open Las Vegas, an exciting step into a different world.

Gambling and games of chance have always merited the attention of the artist: painter, sculptor, or printmaker. The studiously and faithfully compiled gambling images appearing in *The Art of Gambling Through the Ages* have been selected from all quarters of the world and date as far back as the fifth century B.C. The collection encompasses gamblers of every age, race, and sex, playing nearly every game of chance: roulette, blackjack, baccarat, slots, and other casino offerings, as well as non-casino games of wager such as pool, chess, bridge, and backgammon, plus horse racing, boxing, and even stock speculating. Card-playing is the subject most prevalent, with a raft of top-notch art works depicting this most popular form of gambling.

Artists have always been aware of and fascinated by the people caught up in the gambling obsession—men and women gamblers, croupiers, card sharps, wheeler-dealers, cheats, and children. My personal favorite is the formally attired player in grand and gilded gambling casinos. This book has two excellent examples: Contemporaries Raoul Dufy and Max Beckman both painted "Baccarat" subjects; they are the ultimate in the tuxedoed, bare-backed, bejeweled power elite. Today's high roller, casual as an around-the-clock player, does not subscribe to such dictates of decorum and attire.

Many such subjects from the world of risk and reward are addressed in these pages.

Thomas Hart Benton takes a sultry slant on Tennessee Williams' play, *A Streetcar Named Desire*, in "Poker Night."

George Grosz' line drawing of a circle of Nazi officials playing cards is a scathing observation of a distasteful period in recent history.

Henri de Toulouse-Lautrec is represented by a vintage litho, "The Game of Bezique," from 1895.

Two English social critics and satirists, Thomas Gillray and William Hogarth, weigh in with "Two-Penny Whist" and "The Cockfight."

There's a fine selection of surreal works by Redon, Goya, and Balthus; Otto Dix with "Scat Players"; and Daumier's "A Game of Draughts" on wood.

Léger's 1917 World War I industrial piece and the World War II "Soldiers Playing Dice" on a *New Yorker* cover by Will Cotton evoke wartime memories.

Gambling for dead game is depicted by William Sidney Mount's 1837 oil, "Raffling for the Goose," which hangs in the Metropolitan Museum of Art, and John Mix Stanley's 1867 painting, "Gambling for the Buck," which shows Indians at a table playing cards with a dead deer at their feet.

Women gambling pops up frequently in this collection. Georges de La Tour's painting of a woman being cheated is contrasted to the painting of proper ladies seated at cards by Sir John Everett Millais. "Game of Cards" by Abraham Rattner is a strong worthy composition of women, and a young female contemporary artist, Suz Brna, shows us a woman at the table in "Luck of the Draw."

Even children gamblers figure strongly in works like Murillo's 17th-century "Small Beggers Playing Game of Dice"; "Children Playing Cards," a 1631 picture by Dirk Hals; "The Truant Gamblers," by Mount, 1835; "Loto," an 1865 oil by Charles Chaplin; and Frank Schoonover's sympathetically

painted "Boys Playing Craps," from 1903.

The collection is also populated with eight or so Native American tribesmen in gambling situations. Perhaps the artistic interest in Indians of the early West foreshadowed today's burst of Native American casinos.

Let us not forget the working man. Phillip Evergood's Great Depression depiction of gandy dancers playing cards in "The Siding" and George Caleb Bingham's "Raftsmen Playing Cards" are standouts.

Abstract concepts have absorbed gambling themes in paintings and collages, as in Picasso's still lifes and the works of Arp, Gris, and Braque. Gambling features in the titles of Audrey Flack's 1976 "Gambler's Cabinet," Joan Mitchell's "Casino," and Robert Motherwell's "Throw of Dice No. 17."

Religious themes are not overlooked in this collection. Mantegna's "The Crucifixion" in the Louvre shows soldiers shooting dice at the foot of the cross; "Denial of St. Peter" by Georges de La Tour also includes dice throwing.

Other pieces that appear in *The Art of Gambling Through the Ages* are portrait studies, including a full-length abstract of "Card Players" by Picasso in 1915, and Marcel Duchamp's "Portrait of Chess Players" from the Philadelphia Museum. And it would be overly modest of me not to include two Neiman portrait paintings: a "Change Girl" at the slots and a monumental dealer, "Baccarat Girl."

Several pieces I particularly favor include the inventive "Poker Game" serigraph by Israel Rubenstein, and "A Friendly Game" by Fletcher Martin, 1958, "Gambling at the Ridotto" by the Venetian Marchiore, "The Gamble," a 1968 archetypal Romare Bearden, and David Teniers' amusing and far-fetched painting in the Pushkin Museum, "Monkeys Playing Cards." Other eye-stoppers: Norman Rockwell's "The Bridge Game," a bird's-eye view from a *Saturday Evening Post* magazine cover; Jacob Lawrence's excellent "The Pool Game"; and Van Gogh's pool table in "The Night Cafe."

Finally, my 1970 painting of another heavy gambling citadel, "New York Stock Exchange," appears on the last page. The floor of a stock exchange is different from that of a casino, but at both locales, the worlds of work and play converge.

The artist has never overlooked the vast world of gambling, because the artist, too, is a gambler. The artist and the gambler both know the odds. For the payoff, both must go for the pot. You can't hit a big jackpot without a big bet. Where there's a risk factor, there is opportunity, and they usually occur together. You may retard pursuit in view of likely failure, but neither risks nor opportunities present themselves when there is no commitment of chance-taking. It's summed up in an old gambler's expression: "If you don't have action, *nothing* can happen."

With all due respect to the high-rolling gambler, the artist plays a similar high-stakes game, taking chances continually during the very process of painting in order to survive in his God-given profession.

—LeRoy Neiman, September 1999

The Art of Gambling
Through the Ages

POKER NIGHT

1948

Thomas Hart Benton

Born: 1889, Neosho, Missouri, USA Died: 1975

tempera and oil on panel, 36" x 48"

Thomas Hart Benton's early paintings embraced the modern Parisian styles, but he ultimately developed a technique that reflected a predominantly American culture. His paintings celebrate purely American experiences, especially those of the heartland where he was born and raised. Benton's gambling-related paintings are no exception. In his "Poker Night," "Crapshooters" (see page 45), and "Arts of the West" (see page 125), gambling is shown as it was enjoyed in the everyday lives of common people.

Perhaps the greatest of all games—gambling or otherwise—poker combines skill, probability, and psychology like no other contest. Its roots stem from Europe—possible ancestors include England's brag, France's *poque,* and Italy's *primero*—as well as from an old game of Persian origin called *as nas,* but poker is distinctly American. Though "Poker Night"—inspired by a scene from the Tennessee Williams play *A Streetcar Named Desire*—includes women, the traditional home poker gathering depicted here is almost always stag.

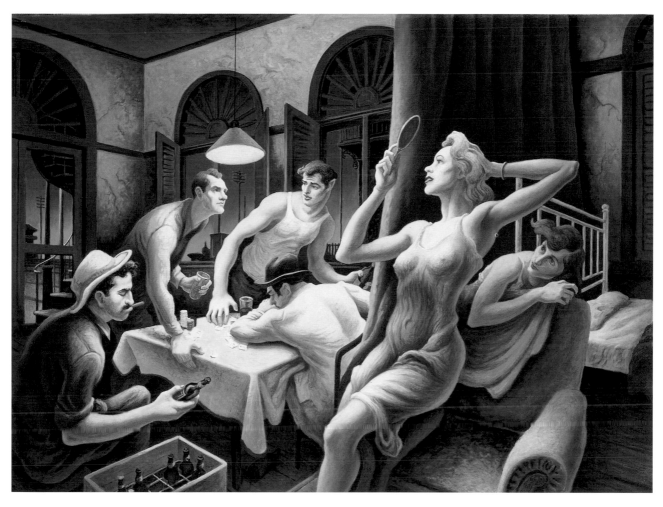

POKER NIGHT, Thomas Hart Benton

THE CHEAT WITH THE ACE OF CLUBS

c. 1625

Georges de La Tour

Born: 1593, Lorraine, France Died: 1652

oil on canvas, 38 ¹/₂" x 61 ¹/₂"

Kimbell Art Museum, Fort Worth, Texas

Most of the paintings of Georges de La Tour were of the Baroque style, characterized by 17th-century court and religious scenes. Strongly influenced by Caravaggio, de La Tour painted numerous night scenes illuminated by candlelight, which added an eerie effect to the settings ("The Cheat" is one of his brighter efforts). During his most productive years, de La Tour was intrigued by gambling and some of the deceptive practices associated with it. During this time, he completed "The Cheat With the Ace of Clubs," as well as a virtual clone, "The Cheat With the Ace of Diamonds." In addition, de La Tour painted at least three other vivid gambling works, including "Card Players," "Denial of St. Peter" (see page 181), and "The Dice Players" (see page 189).

This scene is interesting for two reasons. First for the strong depiction of women gambling with complete acceptance. Many 17th-century artistic portrayals confirm that European women were not excluded from gambling, either among themselves or with men. Central, though, is the obvious cheating theme. The ace about to be reintroduced into the game was "held out" earlier for use at an opportune time. The technique is known as "mucking." The date of this work renders it one of the earliest artistic portrayals of cheating at cards.

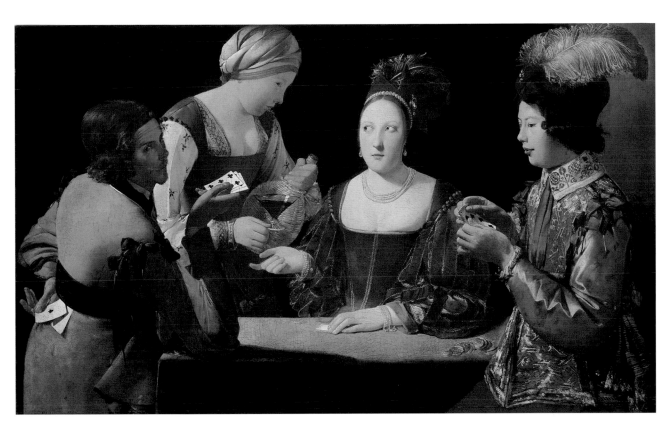

THE CHEAT WITH THE ACE OF CLUBS, Georges de La Tour

GAMBLING FOR THE BUCK

1867

John Mix Stanley

Born: 1814, Canandaigua, New York, USA Died: 1872

oil on canvas, 20" x 15 ⁷/₈"

Stark Museum, Orange, Texas

John Mix Stanley exhibited an early interest in Native American culture as he grew up in the heartland of the Iroquois nation. His father was an innkeeper, and it's believed that local Indians frequented the Stanley tavern. His early exposure to Indian culture is manifest in his specialty—the painting of Indian portraits—and he is considered one of the most prominent artistic chroniclers of the American Indian. Stanley also had a fascination with gambling, especially as it was practiced among American tribal people, and the fertile ground of Indian gaming inspired some of his finest work. "Gambling for the Buck" is regarded as Stanley's best and most popular painting (see also "Game of Chance," page 173). In it, he characterizes the participants as dignified, stately, and handsome subjects, resplendent in their finest buckskin attire.

American Indians were ardent gamblers and game players. While the history of Native American gambling, in general, is well-documented, little has been written about the specific origins of their card-playing, the activity depicted here. Most historians believe that Columbus brought cards with him on his voyage to America; the games were learned subsequently from settlers of the New World.

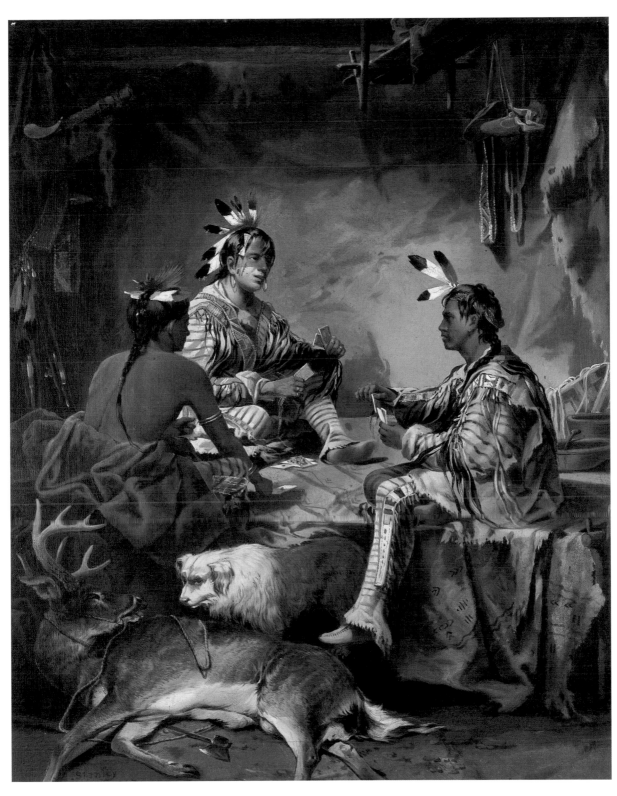

GAMBLING FOR THE BUCK, John Mix Stanley

THE CARD PLAYERS

1892

Paul Cézanne

Born: 1839, Aix-en-Provence, France Died: 1906

oil on canvas, 17 3/4" x 22 1/2"

Musée d'Orsay, Paris, France © Erich Lessing/Art Resource, New York

Paul Cézanne is often referred to as the "Father of Modern Painting." Though his family did not encourage his early efforts as an artist, his father, a banker, provided him with an excellent classical education and financial freedom. While attending the Atelier Suisse in Paris, Cézanne befriended many budding Impressionist painters, but his initial experiences with the Impressionist style were not successful. In fact, his close friend Emile Zola criticized Cézanne's early work in his novel *L'Oeuvre,* in which he characterized him as an unsuccessful artist. Cézanne's dissatisfaction with the Impressionists led him to explore a new painting technique, in which he reduced natural objects to geometrical patterns, and his style is generally believed to have influenced the development of the Cubist movement. Cézanne painted three versions of "The Card Players"; this version was the last and is considered the best of the three.

While there are many theories concerning the origin of cards, most historians believe they were invented in China. Their introduction into Europe is thought to have occurred around the late 13th or early 14th century, probably in Spain by way of travelers from Egypt or Arabia. The card "suits" that were adopted in Cézanne's France—spades, clubs, hearts, and diamonds—first appeared near the end of the 15th century and have survived to become the standard.

See also Cézanne's "The Card Players and Girl" (page 207).

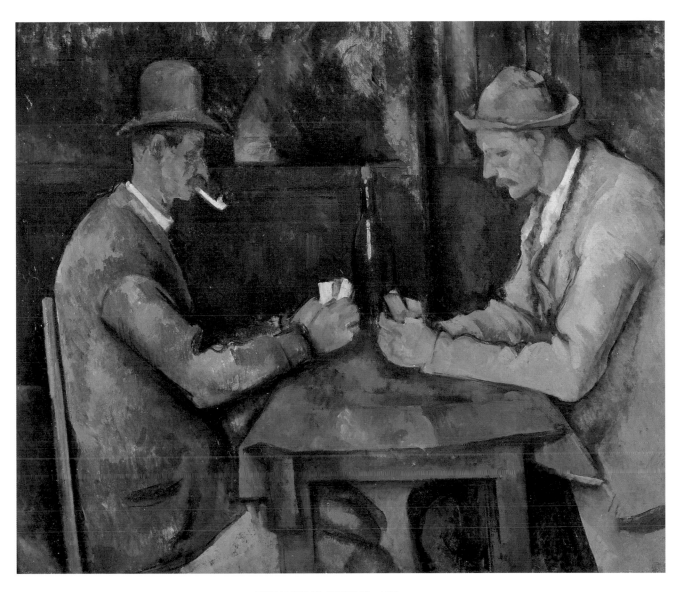

THE CARD PLAYERS, Paul Cézanne

CARD PLAYERS

1913

Pablo Picasso

Born: 1881, Malaga, Spain Died: 1973

oil on canvas, 42 1/2" x 35 1/4"

The Museum of Modern Art, New York. Acquired through the Lillie P. Bliss Bequest
© 1999 Estate of Pablo Picasso/Artists Rights Society (ARS), New York

Pablo Ruiz Picasso learned art from his father, a teacher at the Fine Arts Academy in Barcelona. Around 1906, he and his close friend and associate Georges Braque began experimenting with a new artistic method that combined geometric forms with collage. This procedure gave impetus to the rise of Cubism, a technique pioneered by Paul Cézanne. Picasso's famous "Les Demoiselles d'Avignon" (1907) was one of the first recognized Cubist paintings. In the early 1920s, Picasso developed his own style of Abstraction and Surrealism. During this period, he produced his masterpiece, "Guernica," in which he protested the horrors of war.

While Picasso exhibited no known affinity for gambling, he, like many Cubists of the period, found cards particularly suitable to the technique. His "Card Players" was one of several such images painted by Cubists of the period (see Fernand Léger, page 17; Theo Van Doesburg, page 129; Georges Braque, page 175; and Juan Gris, page 197).

See also Picasso's "Ace of Clubs" (page 151).

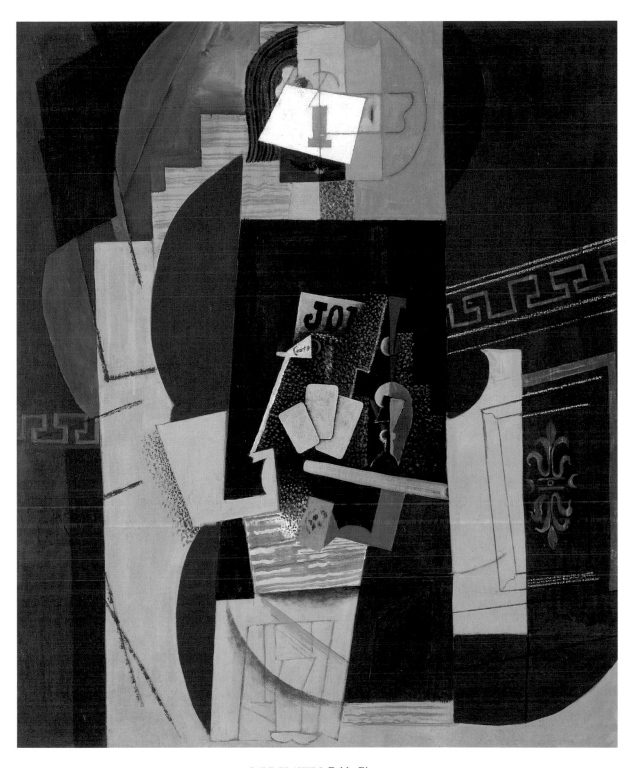

CARD PLAYERS, Pablo Picasso

THE ROULETTE TABLE

1892

Edvard Munch

Born: 1863, Loten, Norway Died: 1944

oil on canvas, 29 1/2" x 45 3/4"

Munch Museum, Oslo, Norway © Erich Lessing/Art Resource, New York

Edvard Munch had a dark childhood, during which he was preoccupied with thoughts of illness and death. His mother died when he was five; his sister, when he was 13. Munch himself declared, "Sickness, Madness, and Death were the black angels who stood 'round my cradle at birth." Munch's style has been referred to as "anguished Expressionism"; his most famous painting, "The Scream" (1893, sometimes titled "The Cry"), was the ultimate reflection of his dark themes. On the other hand, as Munch became famous and received high critical acclaim for his work, he came to be characterized as a life-loving celebrity who spent much of his time in the Bohemian society of Berlin, where he drank heavily and gambled.

"The Roulette Table" is an excellent example of how a painting can provide a snapshot of a period. This scene of well-dressed men gathered around a roulette table is representative of the scene in a European salon, possibly one of the spas in Baden-Baden or Bad Homburg. Given that casino gambling was outlawed in Germany in 1872, however, it's more likely that this is a scene from Monte Carlo, which flourished thereafter. Note the emphasis of the "scorecard," used to track the winning numbers; gamblers of the day were inveterate systems players. A few decades earlier, Dostoevsky wrote his famous *The Gambler,* the story of a man who succumbs to the lures of gambling systems in an attempt to beat roulette.

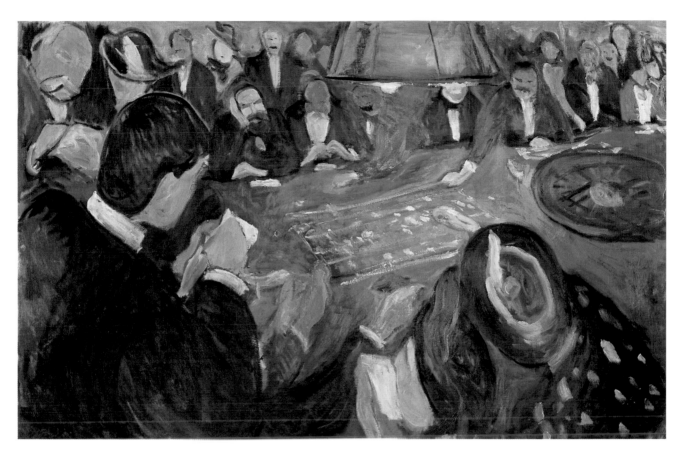

THE ROULETTE TABLE, Edvard Munch

SIOUX SEED PLAYER

1947

Oscar Howe

Born: 1915, Crow Creek, South Dakota, USA Died: 1983

casein on paper, 14^1/$_2$" x 20"

In the collection of the University of South Dakota © Adelheid Howe, 1983

Oscar Howe, a full-blooded Sioux Indian, was born on South Dakota's Crow Creek reservation. One of the first artists to combine European styles and techniques with traditional Native American imagery, Howe is widely regarded as the "Father of the Contemporary School of Indian Art."

Although there are numerous artistic portrayals of tribal people gambling with standard paraphernalia such as cards and dice, Native Americans also concocted imaginative games of chance and devised many of their own gambling tools. They used stones, bones, and sticks for dice, and when necessary employed other natural objects, such as elk teeth, walnut shells, and—as seen in this image—seeds.

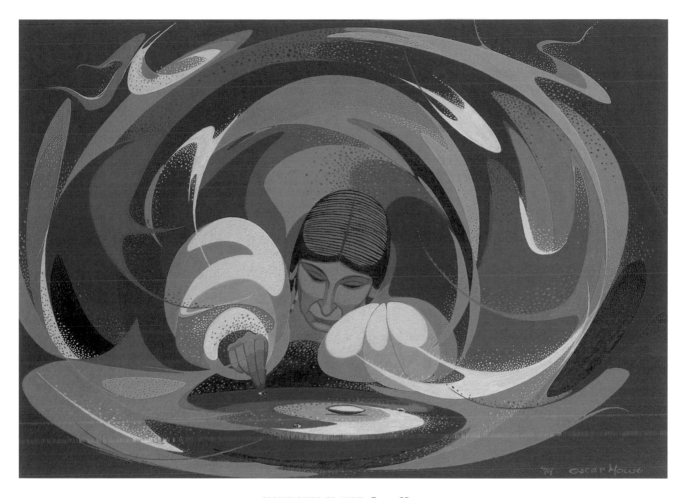

SIOUX SEED PLAYER, Oscar Howe

SOLDIERS PLAYING AT CARDS

1917

Fernand Léger

Born: 1881, Argentan, France Died: 1955

oil on canvas, 129 cm x 193 cm

Kröller-Müller Museum, Otterlo, The Netherlands
© 1999 Artists Rights Society (ARS), New York/ADAGF/Paris

Strongly influenced by the work of Paul Cézanne, Fernand Léger quickly fell under the spell of the Cubist movement. He studied architecture before becoming a painter, and his fascination with machines carried over into his work, earning Léger the label of "Tubist." "Soldiers Playing at Cards," believed to be an homage to Cézanne, is a prime example of Léger's unorthodox style. His French soldiers playing cards in the trenches during World War I are portrayed as disjointed robots, casualties of war with machinery representing body parts, resulting in fragments of humanity. Léger was recovering from gas burns in his lungs in an army hospital in France when he painted the piece. The artistic statement is similar to that of Otto Dix in his anti-war "Skat Players" (see page 21).

The 20th-century rise in the popularity of gambling in the United States is attributed to American GIs learning to play the games during the two world wars. Men in the fighting forces of other nations also spent their idle time playing cards, which resulted in a new generation of gamblers in those countries as well. Notice that the cards do not display "indices," the digits in the corners that represent a card's rank. Though cards with indices were introduced in the mid 19th century, they weren't widely adopted for several decades.

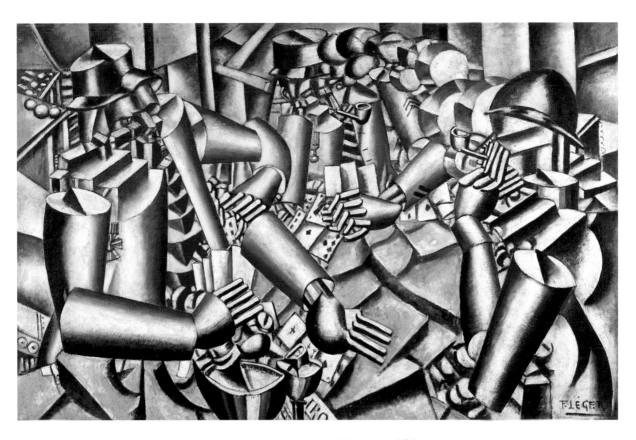

SOLDIERS PLAYING AT CARDS, Fernand Léger

PRUDENCE, AVARICE, LUST, JUSTICE, ANGER

1977

Jack Beal

Born: 1931, Richmond, Virginia, USA

oil on canvas, 72" x 78"

Collection Bayly Art Museum, University of Virginia, Charlottesville

Jack Beal was the son of a parts manager of a Richmond auto dealership. As a child, Beal had a keen interest in art and drawing; he developed his skills while periodically confined to bed with chronic ear infections. He was later accepted as a student at the Art Institute of Chicago, where he met and studied with future artistic luminaries Claes Oldenburg, Richard Estes, and Robert Indiana. Early in his career, Beal was inspired by Cézanne and Matisse, and he painted primarily in the Abstract Expressionist style. After growing dissatisfied with his abstract paintings, he developed a new technique: American Realism.

During the late 1970s, Beal produced a series of allegorical paintings that represented virtues and vices, which included "Prudence, Avarice, Lust, Justice, Anger." Taken in order (from top left), the powerful vice avarice is represented by a gambler. Notice the "hold-out" card (an ace) in the gambler's belt, which he will later use to cheat. Also of note is Beal's choice of a poker table as the battleground, further establishing gambling as an important theme in this work.

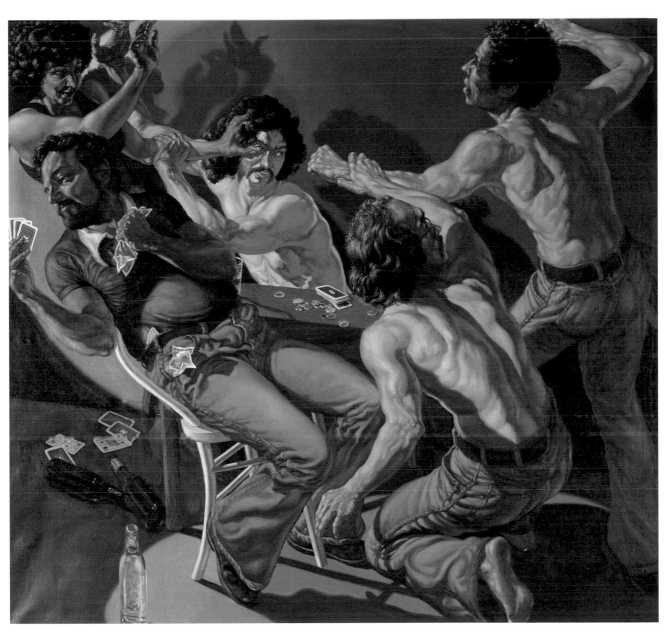

PRUDENCE, AVARICE, LUST, JUSTICE, ANGER, Jack Beal

SKAT PLAYERS

1920

Otto Dix

Born: 1891, Untermhaus, Thuringia (formerly East Germany) Died: 1969

oil on canvas with collage, 43 ³/₈" x 34 ¹/₄"

Berlin, Nationalgalerie, Staatliche Museen Zu Berlin
© 1999 Artists Rights Society (ARS), New York/VG BILD-Kunst-Bonn

Otto Dix' early artistic style was primarily Expressionistic; however, he is frequently referred to as the leader of the "New Objectivism" movement. His canvases, often graphically horrifying, are considered among the most powerful anti-war depictions ever rendered. In "Skat Players," believed to be a parody of Cézanne's "The Card Players," the crippled human figures are composed of collaged pieces representing amputated arms, wooden legs, and disfigured and distorted faces. Dix' intent was certainly to show the grotesque physical and psychological deformities that war can cause.

The game of skat is a national institution in Germany. Dating back to the early 1800s, skat is a three-player game that uses a 32-card deck. It is loosely compared to bridge for its reliance on skill and similarities in play. A streamlined version of skat, along with a similar game that preceded it, sheepshead (or *schafkopf),* has gained popularity in North America in the 20th century. Notice that the cards in this image display the different suits of the German deck: hearts, leaves, bells, and acorns.

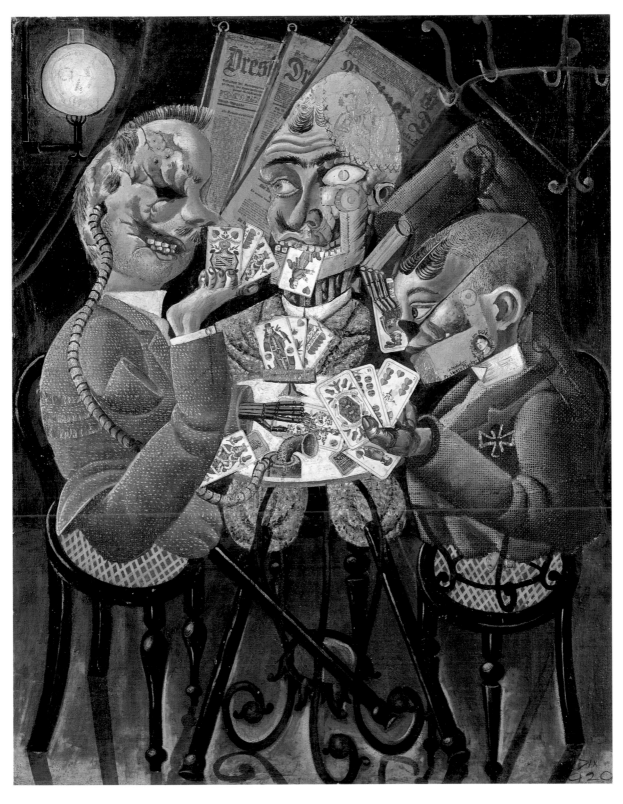

SKAT PLAYERS, Otto Dix

SMALL BEGGARS PLAYING GAME OF DICE

c. 1650

Bartholome Murillo

Born: 1617, Seville, Spain Died: 1682

oil on canvas, 53 ³/₄" x 43 ¹/₄"

Alte Pinakothek, Munich, Germany © Scala/Art Resource, New York

Bartholome Murillo was considered one of the world's premier painters of religious scenes. His work conveyed a deep spirituality, as well as compassion for people of common means. Murillo often painted the poverty-stricken children of his hometown. "Small Beggars Playing Game of Dice" is a typical treatment: Though poor, desperate, and dressed in rags, the boys are portrayed as clean and happy ragamuffins.

The boys appear to be playing craps, a version of which is called "private craps," "alley craps," or sometimes the "fading game," because there is no banker (the function performed by the house in casino or "bank" craps). Given the date and origin of the painting, it's likely the actual game is hazard. The name is derived from *al zahr*, Arabic for dice, which were introduced to Europe by Saracen invaders following the Crusades. The six-sided cubes worked their way through Europe to France; a total of two was called "crabs," which was later Anglicized into "craps."

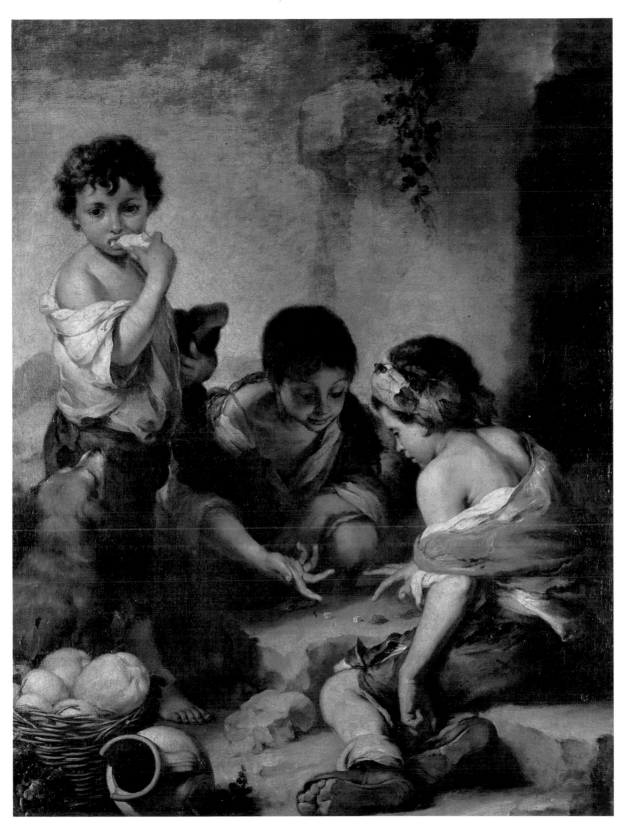

SMALL BEGGARS PLAYING GAME OF DICE, Bartholome Murillo

THE GREEN TABLE

1972

LeRoy Neiman

Born: 1927, St. Paul, Minnesota, USA

oil on canvas, 72" x 48"

Collection of the Artist

LeRoy Neiman is the foremost artistic chronicler of the great American entertainment pastimes of the 20th century. From the 1950s to the present day, Neiman has recorded on canvas the things that most capture the imaginations of the American people: sports, celebrities, bar and lounge scenes, and gambling. Via his art, he has documented the Super Bowl, the Olympics, the greatest fights and horse races of the century, even Playboy Bunnies. He is, in a sense, a true historian of America's leisure behavior. Neiman's ever-growing collection of gambling art mirrors the explosion of wide-open gambling in America, and his style infuses the one element often missing in portrayals by other artists—glitz. "The Green Table" is only one of many visually stimulating gambling settings he has painted. See also Neiman's "Baccarat Girl," "Change Girl," and "Sic Bo" (page 35); "World Series of Poker" and "Stud Poker" (page 55); "Vegas Craps" (page 75); "Neiman's Golden Nugget" (page 119); "D.I. Baccarat" (page 155); "Vegas Blackjack" (page 201); "Introduction of Champions at Madison Square Garden" (page 225); "Ascot Finish" (page 227); and "New York Stock Exchange" (page 231).

"The Green Table" depicts last-second betting action as the dealer prepares to launch the roulette ball. The scene is a busy table in a casino in Europe, where roulette has always enjoyed greater popularity than it does in America. The name roulette is French, and loosely translated means "little wheel." While it's known that wheel-like devices were used for gambling as far back as the days of the Roman Empire, the precise origins of roulette have never been established. Many credit the French mathematician Blaise Pascal with its invention circa 1650, but evidence supporting this theory is sparse; moreover, the game as it's known today didn't show up in French gambling houses until a century later. Considered a descendent of several forerunners, including *hoka, biribisso, boule,* and an English game called EO (even odd), roulette became the premier gambling game of 19th-century Europe.

THE GREEN TABLE, LeRoy Neiman

NOT A CHINAMAN'S CHANCE

c. 1893

Charles M. Russell

Born: 1864, Oak Hill, Missouri, USA Died: 1926

sculpture: wax on wood and cloth base, height 10 3/4", base 12" x 19"

Amon Carter Museum, Fort Worth, Texas

Though encouraged by his father, a successful businessman, to get a formal education and take over the family business, Charles Marion Russell was fascinated with the American West and was intent on becoming a cowboy. His dream came to fruition when he migrated west as a teenager and made it his home until he died. Russell, along with Frederic Remington, became one of the pre-eminent artists portraying the Wild Wild West. In 1888, Russell met and befriended a cowboy named "Long Green" Stillwell, who also was an itinerant faro dealer. Stillwell provided Russell's introduction to the world of gambling, and the artist's fascination with games of chance is documented in several of his paintings and sculptures.

"Not a Chinaman's Chance" was preceded by a companion piece titled "The Poker Game" (see page 203), which represents the beginning of a round of cards played by the same trio of a cowboy, an Indian, and a Chinese man. "Not a Chinaman's Chance" depicts the end of the hand. It can be inferred that the Oriental man has dropped out ("folded") and no longer contests the pot, hence the title.

See also Russell's "Letter to Friend Thed" (page 69) and "Letter to Friend Cal" (page 171).

NOT A CHINAMAN'S CHANCE, Charles M. Russell

THE GAMBLERS
1943
Fletcher Martin

Born: 1904, Palisade, Colorado, USA Died: 1979

oil on canvas, 30" x 40"

Courtesy of Mrs. Jean Martin Wexler, East Hampton, New York

Whereabouts of work unknown

The son of a printer and an editor of various small-town newspapers, Fletcher Martin left high school and acquired an informal education traveling throughout the West as a hobo. He was a self-taught artist who sketched and drew everything he saw as he rode the rails. At 17 years old, he lied about his age and joined the Navy, where he was a fairly successful light heavyweight boxer for the fleet. He eventually settled in Los Angeles, becoming close friends with writers William Saroyan and Budd Schulberg. In 1941, Martin was appointed successor to Thomas Hart Benton as head of the Department of Painting at the Kansas City Art Institute. Martin was both an artist and a gambler, and he used gambling as a theme in some of his finest paintings, including "The Gamblers," "Urchin's Game," "Temptation in Tonopah," "Small Businessman" (see page 137), and "Friendly Game" (see page 163).

In "The Gamblers," Martin depicts soldiers doing what they often did when they were bored and had time on their hands—they gambled. The dominant poker variation of the time was five-card draw, and all the elements of the game are seen here: five cards in each hand, the "discards," and the "pot" of paper money. Another possible game is red dog, which was extremely popular among World War II soldiers, as was blackjack.

SQUARES ARRANGED ACCORDING TO THE LAWS OF CHANCE
1917
Jean Arp

Born: 1886, Strasbourg, France Died: 1966

cut and pasted paper, ink, and bronze paint, 19 ½" x 13 ⅝"

The Museum of Modern Art, New York. Gift of Philip Johnson

© 1999 Artists Rights Society (ARS), New York/VG BILD-Kunst-Bonn

The French sculptor and painter Jean Arp was one of the founders of the Dada and Surrealist art movements. During his Dada period, he worked primarily on collages, experimenting with works created by chance. While constructing "Squares Arranged According to the Laws of Chance," Arp is said to have torn up one of his paintings, dropped the pieces on the floor, and glued them together the way they fell. He referred to the finished work as a "collage of randomness." Later in his career, he devoted most of his time to sculpture.

Gambling is ruled by the laws of probability, or chance, and the critical concept of randomness is present in most games. While absolute randomness in gambling is virtually impossible to achieve, it is approximated with a high degree of success—from basic card shuffling to the sophisticated "random-number generators" used in slot machines.

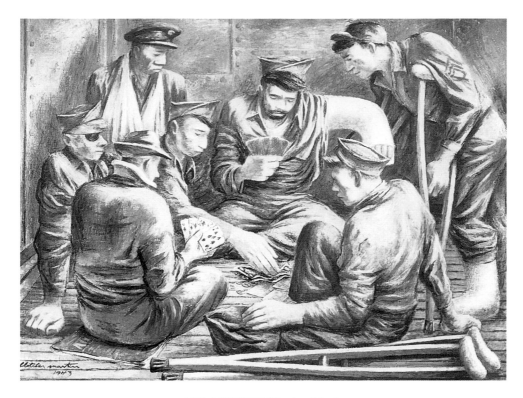

THE GAMBLERS, Fletcher Martin

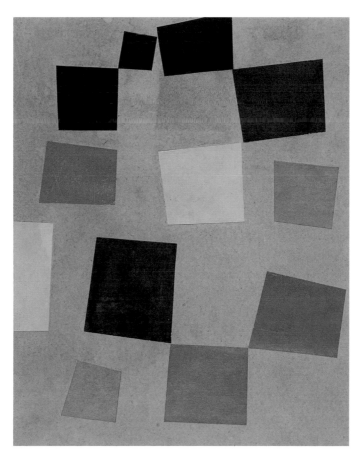

SQUARES ARRANGED ACCORDING TO THE LAWS OF CHANCE, Jean Arp

GAMBLERS QUARRELING

1665

Jan Steen

Born: 1626, Leiden, Holland Died: 1679

paint on canvas, 69.9 cm x 88.3 cm

Gift of James E. Scripps, the Detroit Institute of Arts

Jan Steen was a highly esteemed Dutch artist who portrayed his own life as he lived it. Before he trained as a painter, he followed in his father's footsteps as a local brewer, which gave young Steen ample material for artistic expression. Once he determined that he wanted to be an artist, he studied seriously in the same local school of painting that produced his close friend and later partner, Jan Lievens, as well as the great Dutch Master Rembrandt van Rijn. Jan Steen's raucous and jolly tavern and brothel settings were successful because he was capable of mixing the vulgar with the high and mighty, the comic with the tragic, and the serious with the satirical. He spent most of his later years engaged in heavy drinking with his lifelong colleague, Lievens.

The exact card game being played when the melee began is difficult to determine. A Dutch game called *klaverjas,* a relative of the Swiss game of *jass,* is ruled out by the presence of the five on the table; games in the *jass* family are played with 32-card decks devoid of fives. Notice also the toppled backgammon board in the foreground, further evidence of the popularity of gambling and games in taverns, brothels, and similar settings.

See also Steen's "The Card Players" (page 215).

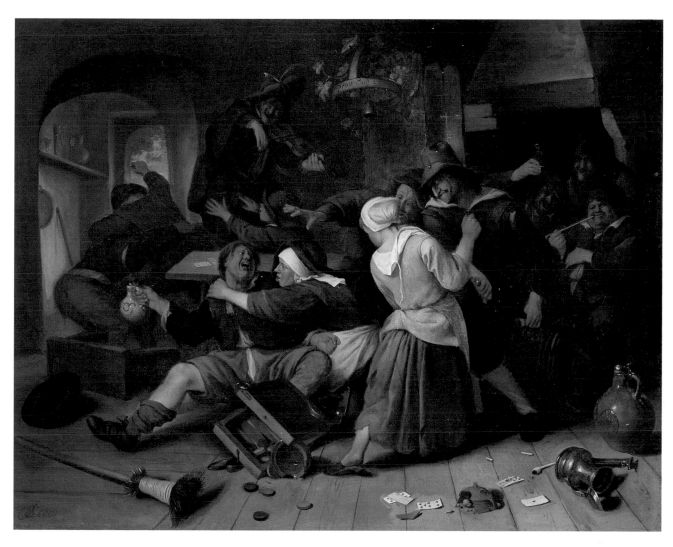

GAMBLERS QUARRELING, Jan Steen

GAMBLERS QUARREL

1984

Stephen Goodfellow

Born: 1953, Southhampton, England

acrylic, primary micropointillism

Courtesy of the Artist

Stephen Goodfellow was born in England, lived in several countries around the world, then settled with his family in Detroit, Michigan. At age 15, he was accepted to East Ham Technical College in London. He later returned to Detroit, where he continues to refine his Primary Micropointillism technique, which uses microdots of color, much as Georges Seurat did in his Pointillism style, to produce "incredibly vibrant color."

In a modern takeoff on Jan Steen's 1665 painting, "Gamblers Quarreling" (see page 31), Goodfellow mimics Steen's gambling scene but substitutes a Monopoly board for cards. Monopoly is an excellent example of a popular non-gambling game that can easily be used for gambling purposes. When it is, skilled gamblers have a dual advantage. Since Monopoly is deeply rooted in probability, an expert strategy can be formed and implemented. But because the relationship to mathematics is not obvious, losing players attribute a poor outcome to "bad luck." As a result, much like a backgammon hustler, a skilled Monopoly player can preserve money-making opportunities for extended periods of time.

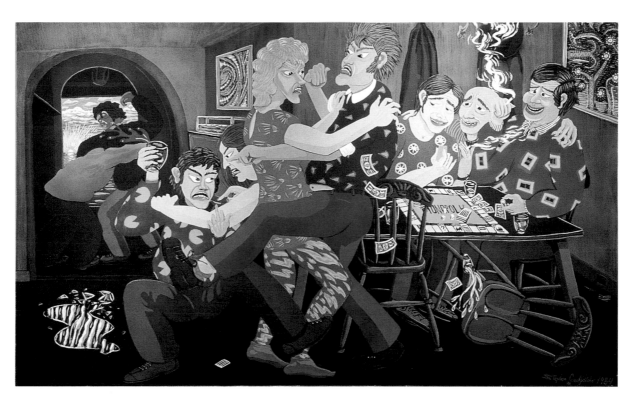

GAMBLERS QUARREL, Stephen Goodfellow

CAESARS GIRLS

1980

LeRoy Neiman

Born: 1927, St. Paul, Minnesota, USA

oil on board, 48" x 36"

Collection of Caesars Palace

For biographical information about LeRoy Neiman, see page 24.

These three "of nine or so" paintings by LeRoy Neiman for a casino-commissioned series depict working women at Caesars Palace in Las Vegas.

BACCARAT GIRL

The presence of this stately female baccarat dealer is neither an accident nor an aberration. Beautiful women have been employed by the casinos for decades to adorn their baccarat pits, originally as "shills"—employees who pose as players to stimulate action—and more recently as dealers. One of the great stories to come out of the baccarat rooms has little to do with the game. In 1991, a group of eight dealers from the Las Vegas Hilton turned an initial $80 stake ($10 per person) into $103,000 by betting one NFL football game per week, parlaying their winnings, and winning 11 consecutive bets. The dealers' goal was to continue their parlay until they either lost, or reached 15 straight wins. Had they been successful, the group would have cashed a $1.3 million profit. Alas, they lost in week 12. The two baccarat dealers who made all the winning picks were women.

CHANGE GIRL

The change girl is an integral part of the casino workforce. Her job is to change paper money into coins for the slots, while also acting as a front-line ambassador for the casino. She can be summoned by activating a "change light" at the top of a machine. The change girl somehow survives despite advances in machine technology—such as bill acceptors and coinless slots—that threaten to eliminate her necessity.

SIC BO

Sic bo, which means "dice pairs," is an Oriental game played with three dice. It has the properties of other three-dice games, such as grand hazard and chuck-a-luck, only it's spiffed up in the casino with a fancy layout and flashing lights. Sic bo, along with pai gow and pai gow poker, is offered by the casinos to attract Asian gamblers. As it's normally played, sic bo has a house advantage that varies from less than 3 percent to almost 50 percent.

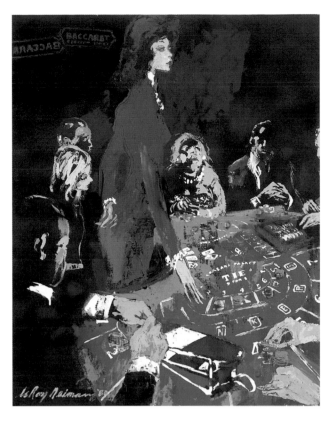

BACCARAT GIRL, LeRoy Neiman

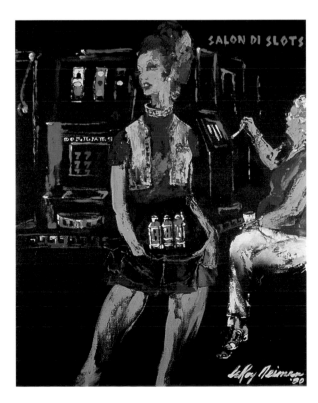

CHANGE GIRL, LeRoy Neiman

SIC BO, LeRoy Neiman

A GAME OF DRAUGHTS
1860
Honoré Daumier
Born: 1808, Marseilles, France Died: 1879
painting on wood, 26.5 cm x 34 cm
Whereabouts of work unknown

Honoré Daumier became an artist at the urging of his father, an underemployed restorer and framer of paintings. Daumier began working to help support his family at an early age. In his free time, he studied drawing and later worked as a cartoonist for the magazine *La Caricature*. Some art historians attribute the early development of the use of satire in cartooning and caricature to his efforts. Daumier began receiving accolades for his great paintings only after his death; since then he has been accorded his place next to such greats as Courbet, Delacroix, and Ingres.

Draughts, or checkers as the game was originally known because of the pattern of checks on the board (it's still called checkers in the United States), is one of the oldest of all board games. While there are scattered reports of the board pattern turning up several centuries before the Common Era, the game in its current form seems to have surfaced in Europe around the late 14th century. While it's safe to assume that wagers have been made over checkers for hundreds of years, some of the earliest documentation of the game being used specifically for gambling dates back to play among American Indians. It's common in big U.S. cities for skilled players—"checkers hustlers"—to congregate in public outdoor areas and play for stakes.

TWO CARDPLAYERS
1913
Max Buri
Born: 1868, Bern, Switzerland Died: 1915
oil on canvas, 121 cm x 150 cm
Whereabouts of work unknown

Compared to the big names in Swiss painting (e.g., Arp, Hodler, Klee, and Giacometti), the name Max Buri evokes little recognition, except among art lovers familiar with his portrayals of the Swiss countryside, city customs, and family gatherings. Buri studied art in Munich and Paris, where later in his career his work was awarded many accolades. Buri might have received wider appreciation and recognition had he not died in an accident in 1915 at the age of 47.

The national card game of Switzerland is *jass,* and several elements of the two-player version, *klaberjass,* are present in this image. Variations of *klaberjass,* all played with a 32-card deck, include *clabber, clobber, clob, clab, klab, klob,* the Hungarian *kalabrias,* and the French *belote.* Regardless of whether it's the game depicted here, *klaberjass* in all its forms was a huge gambling game, some say the most popular two-handed money game in the world prior to the rise of gin rummy.

36

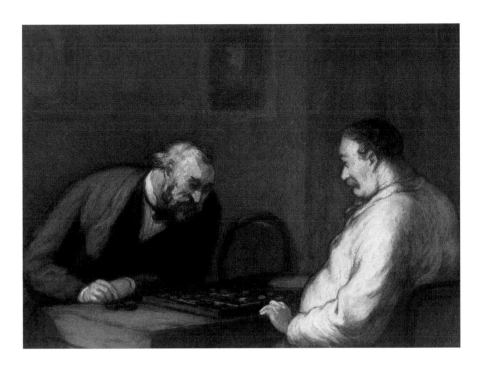

A GAME OF DRAUGHTS, Honoré Daumier

TWO CARDPLAYERS, Max Buri

AJAX AND ACHILLES PLAYING DICE

c. 530 B.C.

Exekias

painted terra cotta black-figure amphora, height 24"

Museo Nazionale di Villa Giulia, Rome, Italy © Nimatallah/Art Resource, New York

Other than his birthplace, which was Athens, Greece, not much is known about painter and potter Exekias. His work represents black-figure painting at its best, and Exekias was one of the most renowned painters of the style during his time. The Ajax and Achilles figures are drawn from the heroic stories of the Trojan War.

While Exekias' painting clearly demonstrates that the Greeks used dice more than 500 years before the birth of Jesus, close inspection reveals that the pictured objects are not the cubes recognized as dice today, but probably bones. Evidence of objects that served as dice dates back to more than 2000 B.C. Cubical dice came to prominence in Rome during the latter 1st century B.C., though they had been developed and used hundreds of years earlier. The phrase "rolling the bones" is still common today.

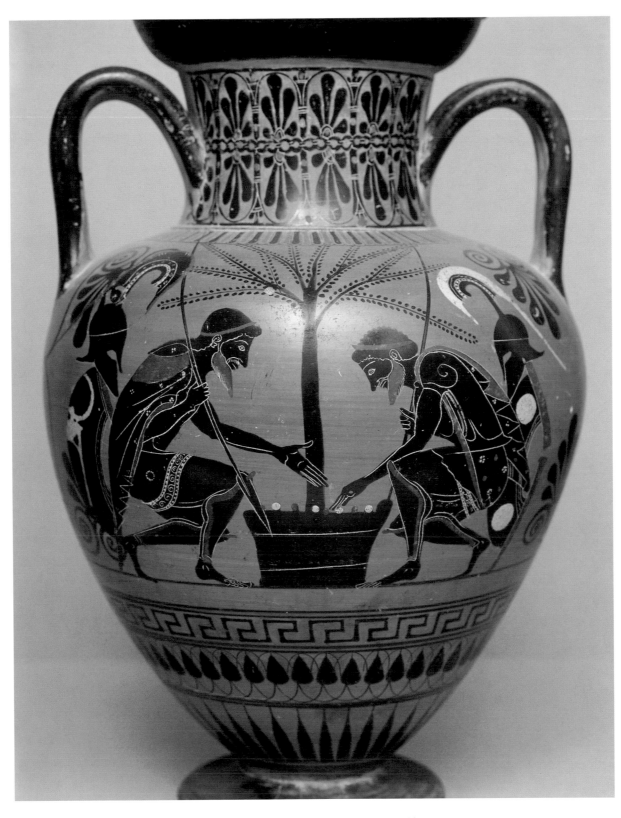

AJAX AND ACHILLES PLAYING DICE, Exekias

THE WHEEL OF FORTUNE

1992

Zara Kriegstein

Born: 1952, West Berlin, Germany

color lithograph (edition 60), 30" x 24"

Courtesy of the Artist, Santa Fe, New Mexico

Born and educated in Germany, Zara Kriegstein was profoundly influenced by the German Expressionist Otto Dix. In fact, Berlin's *Tip Magazine* called Kriegstein's work "a verity of intensified ugliness and obscenity, à la Dix." The artist describes the scene in "Wheel of Fortune": "I saw the hypnotized gamblers feeding their winnings back into the machines, the sexy ladies totally ignored by the possessed players— time, sex, and reason do not exist in this kingdom." Kriegstein currently resides and works in Santa Fe, New Mexico.

This image's title subject is also known as the "big wheel," "money wheel," or "big six." While there's evidence that gypsies transported the game to Europe from India, the wheel of fortune actually rose to prominence as a carnival game in the United States. Carnies loved the wheel for its high house advantage and concocted many variations on the spinning-wheel theme. In one version, a live mouse was released at the top of the wheel, with winners determined by the hole the mouse ran into (these were called "rat wheels"). The wheel of fortune made an easy transition into the casinos, because players were familiar with (and unintimidated by) the game; it still ranks as one of the worst gambles in the house. Note that the artist has elected to use a roulette layout, rather than the standard big six felt, in front of the wheel.

See also Kriegstein's "The Dance of Death Is Forbidden" (page 105).

THE WHEEL OF FORTUNE, Zara Kriegstein

THE LONGHORN SALOON

1919

Walt Kuhn

Born: 1880 Died: 1949

oil on canvas mounted on board, 20" x 24"

Gift of Vera and Brenda Kuhn, Colorado Springs Fine Arts Center

Walt Kuhn became intrigued with the Western United States when he was a little boy. As soon as he was old enough, he began traveling extensively through the West. Whenever he found a town or an area that interested him, he would take a job there and spend enough time to learn the locals' customs and lifestyles. Unlike many painters who portrayed the West as a romantic fantasy, Kuhn's work was authentic and representational; he saw the West as a raw land of cavalry and Indian battlefields, saloons and brothels, seductive maidens, and devious, mustached, shifty-eyed gamblers.

In the West that Kuhn characterized, saloon gambling was a mainstay. Throughout the latter 19th century, colorful gamblers with even more colorful names plied their trade in the gambling towns of Deadwood, South Dakota; Dodge City, Kansas; Tombstone, Arizona; and Virginia City, Nevada. Legendary gamblers of the period included "Wild Bill" Hickok, "Doc" Holliday, "Black Jack" Ketchum, and Bill "Bet a Million" Gates. The women gamblers were equally famous, among them Alice Ivers ("Poker Alice"), Eleanora Dumont ("Madame Moustache"), and Myra Maybelle Shirley ("Belle Starr").

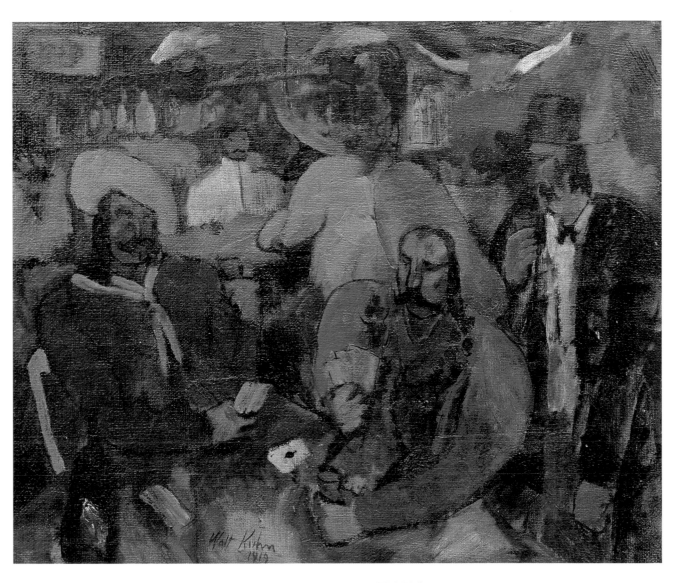

THE LONGHORN SALOON, Walt Kuhn

CRAPSHOOTERS

1928

Thomas Hart Benton

Born: 1889, Neosho, Missouri, USA Died: 1975

tempera with oil on canvas mounted on panel, 48" x 36"

The Nelson-Atkins Museum of Art, Kansas City, Missouri (bequest of the Artist)
© T.H. Benton and R.P. Benton Testamentary Trusts/Licensed by VAGA, New York, New York

For biographical information about Thomas Hart Benton, see page 2.

The game of craps as it's played in casinos today is credited as an American invention. When the European game of hazard came to New Orleans via French traders in the early 19th century, the rules were simplified to create craps. It was originally a non-banking game in which any number of participants could offer and accept ("fade") bets among themselves; it required no special layout, only a pair of dice. The initial banking version of craps was devised in the early 1900s, but the private game remained popular through World War II.

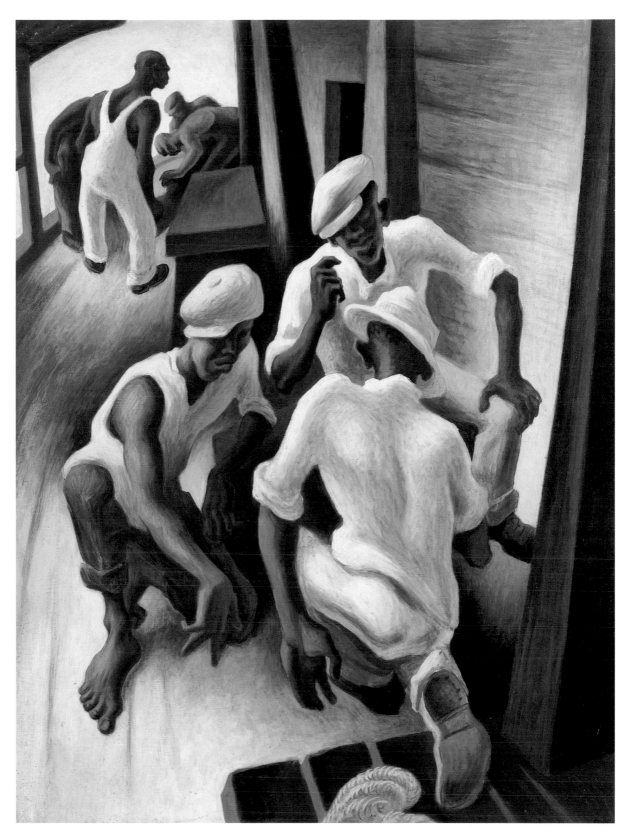

CRAPSHOOTERS, Thomas Hart Benton

CYBER-VEGAS

1995

Steve Speer

Born: 1960, New York, New York, USA

3-D graphics software

Courtesy of the Artist

Today's computer technology offers a plethora of innovative graphic arts and computer painting techniques to the modern artist. Steve Speer is one of these groundbreaking artists, deemed a pioneer in the field of digital and new media. Speer's animation works have been broadcast internationally, and his fine art has been exhibited at New York's SoHo Guggenheim and the San Francisco Museum of Modern Art.

Speer's "Cyber-Vegas" coalesces the gambling industry's current emphasis on high-tech devices and the early evolution of virtual gambling. Internet casinos enable players to participate in any game for almost any stakes, without the attending overhead of running a real casino. Gamblers can place a bet simply by establishing an e-account and logging on. The Internet gambling industry is growing; however, it remains to be seen to what degree players will be satisfied gambling at their computers, in their own offices or dens, alone.

CYBER-VEGAS, Steve Speer

THE CUE AND THE BALL

1956

Jacob Lawrence

Born: 1917, Atlantic City, New Jersey, USA

gouache on paper, 30 ½" x 22 ½"

Hirshhorn Museum and Sculpture Garden, Smithsonian Institution, gift of Joseph H. Hirshhorn, 1966

Jacob Armstead Lawrence was born in Atlantic City. His father was a railroad company cook who was away more than he was home. His parents soon separated and his mother moved the family to New York, where they settled in Harlem around 1930. Lawrence began his education in public schools and later studied with Charles Alston at the Harlem Art Workshop. Much of Lawrence's painting apprenticeship was spent in WPA art classes and the WPA Federal Art Project. These early experiences were reflected in his paintings about work ("Cabinet Makers") and leisure-time activities ("The Cue and the Ball"). But Jacob Lawrence is most famous for his artistic portrayal of African-American struggles: the "Harriet Tubman" series, the "Migration of the Negro" series, and the "Harlem" series.

Gambling over various forms of billiards is common throughout the world. The American version, which uses tables with six pockets, is called pool, or pocket billiards. The classic tavern gambling game is eight-ball, though nine-ball and one-pocket are also popular "money games." Evidence that gambling is involved here is the string of checkers above the table, which can be used to tally results for the settling of wagers.

See also Lawrence's "The Green Table" (page 95) and "The Pool Game" (page 141).

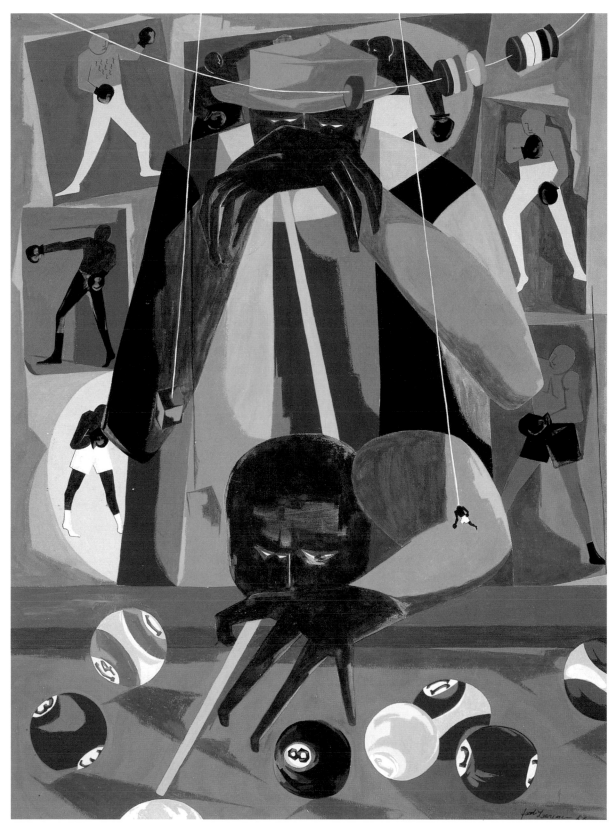

THE CUE AND THE BALL, Jacob Lawrence

THE TRUANT GAMBLERS

1835

William Sidney Mount

Born: 1807, Setauket, New York, USA Died: 1868

oil on canvas, 24" x 30"

© Collection of the New York Historical Society, New York, New York

Raised on a farm on Long Island until he was 17 years old, William Sidney Mount saw little future in agriculture. Instead, he became an apprentice to his brother, a sign painter in New York City. In his spare time Mount practiced drawing, using pencils and chalk. He later enrolled in the National Academy of Design, and for many years supported himself by painting portraits. Although he is best known for his portrayals of rural life, Mount exhibited a keen interest in various games of chance.

The truancy element of this image is stronger than the gambling, which, due to the absence of normal gambling paraphernalia such as dice or cards, is indeterminate. Notice the inverted straw hat, with pennies stacked below and to the left of it. Given Mount's interest in raffles and lotteries (see "Raffling for the Goose," page 113), the boys may be using the hat to conduct a small numbers or lottery game.

See also Mount's "The Card Players" (page 71).

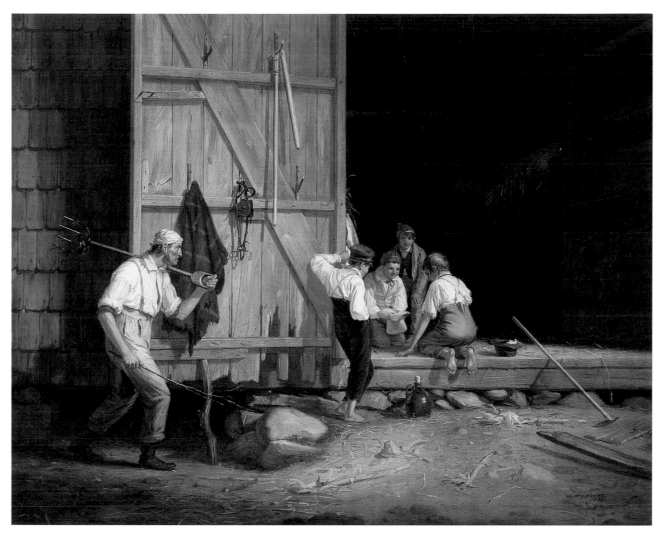

THE TRUANT GAMBLERS, William Sidney Mount

THE GAMBLERS

1623

Hendrick Terbrugghen

Born: 1588, The Netherlands Died: 1629

oil on canvas, 33" x 44 7/8"

The William Hood Dunwoody Fund, the Minneapolis Institute of Arts

The realistic style of Caravaggio attracted many followers, among them Hendrick Terbrugghen. There is no question that "The Gamblers" was inspired by Caravaggio's "The Cardsharps" (see page 73) and Baburen's "Backgammon Players" ("The Gamblers" was painted while Terbrugghen and Baburen shared a studio). Art historians have speculated that the gaming scenes portrayed by Terbrugghen, as well as by Caravaggio and other of his followers, were greatly influenced by images of gambling at the foot of the cross during the Crucifixion of Christ (see Andrea Mantegna's "Crucifixion," page 183).

Terbrugghen's rendering is one of many that have been painted with the dice misspotted. Notice that each die in this image displays a three and a four on adjoining sides. All dice are made so that the opposite sides add up to seven. This practice was begun by the ancient Greeks and has been universal for 2,000 years.

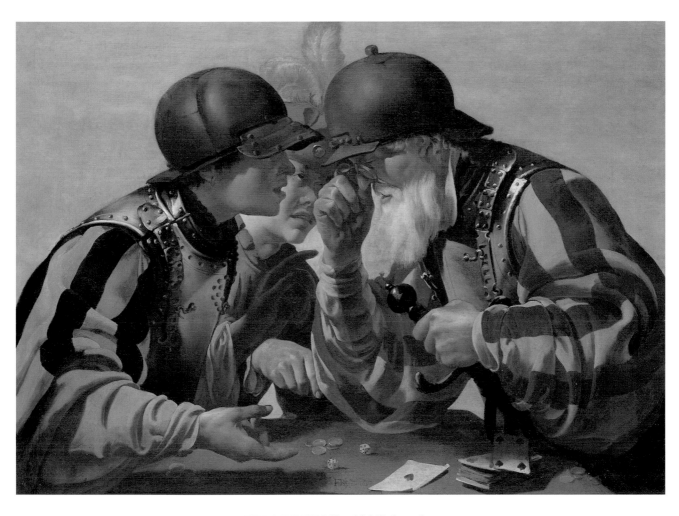

THE GAMBLERS, Hendrick Terbrugghen

For biographical information about LeRoy Neiman, see page 24.

One of the great competitions in all of gambling is the World Series of Poker, played annually at Binion's Horseshoe in Las Vegas. Having sprung from a two-man challenge in 1949, in which Johnny "the Grand Old Man" Moss defeated Nick "the Greek" Dandolos in a marathon match encompassing multiple poker variations, the tournament (which comprises 20-plus competitions) now draws several thousand players and spectators. The main event, the world championship, is contested over a game of no-limit Texas hold 'em—the buy-in is $10,000 and the winner's prize is $1 million. Pictured in this drawing are (from left) two-time world champion Doyle "Texas Dolly" Brunson, world champion Jack "Treetop" Straus, and Sid Wyman, a legendary casino boss who ran the Sands, the Royal Nevada (later the Stardust), and the Dunes.

This image by LeRoy Neiman was also produced as an etching.

"Stud," sometimes called "open," poker is a variation of the game in which some cards are exposed prior to the conclusion of betting. The most popular versions of stud poker are five-card and seven-card. In five-stud, one card is dealt down and four cards are dealt up. In seven-stud, three cards are dealt down and four up. This portrayal is of a private game at a club in London. The players are all men, but the seated "lady in waiting" is a common sight at such games and a staple of Neiman's gambling scenes.

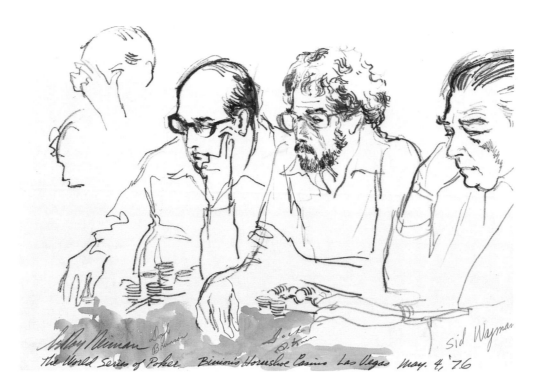

WORLD SERIES OF POKER, LeRoy Neiman

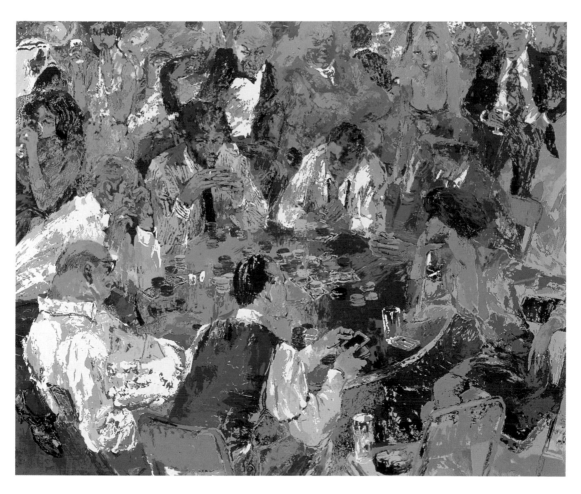

STUD POKER, LeRoy Neiman

THE GAMBLER

1879

Odilon Redon

Born: 1840 Died: 1916

lithograph, 10 1/2" x 7 3/4"

Bibliothèque nationale de France, Paris

Odilon Redon was less known than other Impressionist painters of his period. His early work, which depicted images that were ominous, menacing, and sinister, was considered too different from the mainstream Impressionists. Around 1884 he produced a set of drawings that brought worldwide attention to his "fantastic visions," and revealed his ability to perceive the relationship between imagination and nature. His career took an upward turn when he was noticed and adopted by the Symbolists and Decadents. Later in his career, Redon's achievements earned him the friendship of such notable artists as Matisse, Bonnard, and Vuillard.

While "The Gambler" may have been inspired by nothing more than a personal setback associated with chance, Redon's compelling image of a man bearing the weight of an enormous die could also be one of the first great artistic anti-gambling statements.

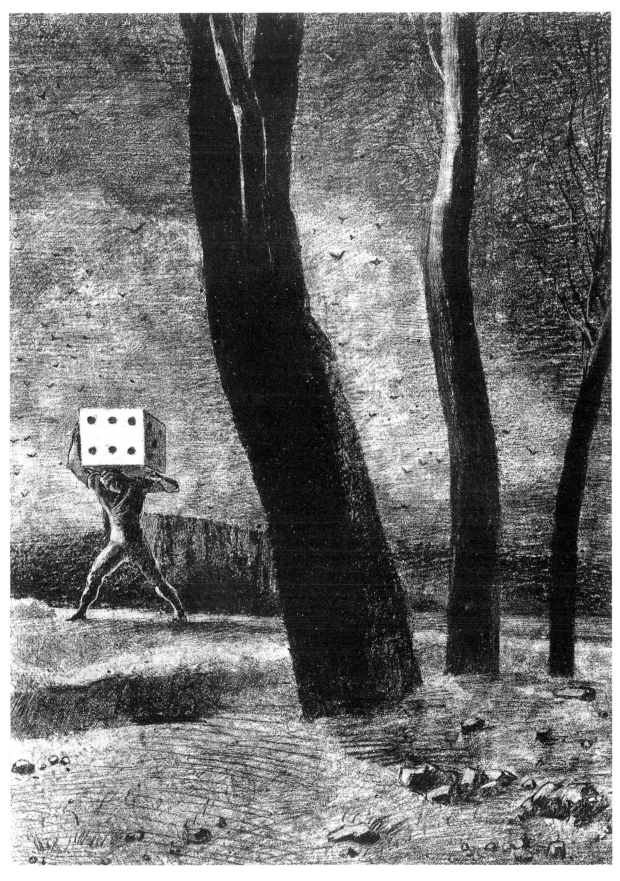

THE GAMBLER, Odilon Redon

BOYS PLAYING CRAPS

1903

Frank Schoonover

Born: 1877, Oxford, New Jersey, USA Died: 1972

charcoal, Chinese white, and wash on illustration board, 8 1/2" x 13 3/4"

Sewell C. Biggs Museum of American Art, Dover, Delaware

Frank Schoonover was born in a small New Jersey mining town that produced iron ore; his father supervised the blast furnace. Though his family had no history of artistic influence, Schoonover exhibited an early interest in sketching streams and bridges while growing up in Trenton. During his early 30s, he toured Europe and studied the great masters, then returned home and enrolled in Howard Pyle's Drexel Institute to become an illustrator-painter. Schoonover's most memorable compositions portray the American West and the Canadian wilderness. During the latter part of his career, he illustrated a number of children's books and classics, including *Robinson Crusoe, Kidnapped, Heidi, Gulliver's Travels, Swiss Family Robinson,* and *Grimm's Fairy Tales.*

This depiction of young dice players is curious, given the time period, for the appearance of three dice. The title of his painting notwithstanding, Schoonover may be portraying a gambling game called "four five six," in which three dice are used. The game was popular in Western Canada, where Schoonover spent time and produced several works.

See also Schoonover's "Playing Cards in a Tent" (page 167).

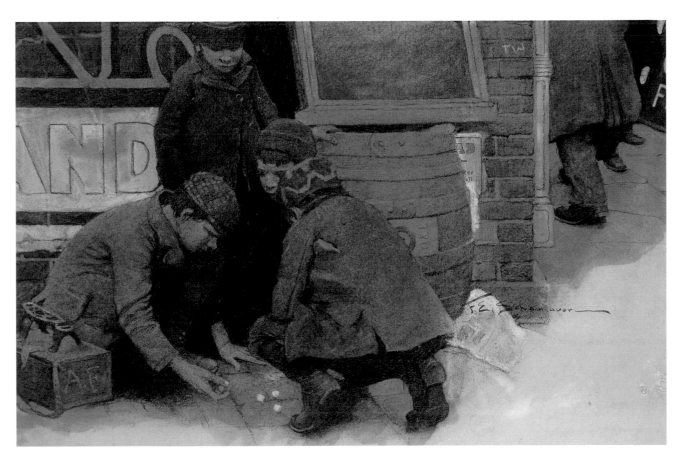

BOYS PLAYING CRAPS, Frank Schoonover

A MISDEAL
1897
Frederic Remington
Born: 1861, Upstate New York, USA Died: 1909
oil on canvas, black and white, 26" x 40"
Courtesy of Frederic Remington Art Museum, Ogdensburg, New York

An only child, Frederic Remington grew up admiring his father, a genuine Civil War hero, and developed a love of horses and an interest in the military. Remington also aspired to be an artist, and though he showed little early promise in drawing, his parents sent him to Yale Art School, where he stayed only briefly. He traveled the West as a young man and honed his artistic skills when he became an illustrator and correspondent in Cuba during the Spanish-American War. Over the years Remington developed into a highly regarded professional illustrator of Western-genre subjects, known especially for his honest and unprejudicial portrayals of Indians and black cavalrymen. Today, he is renowned as one of the premier artists of the Wild West.

Gambling in the Old West was a dangerous activity, as games sometimes culminated in gunplay. By far the most famous card-game shooting was that of "Wild Bill" Hickok on August 2, 1876, in Deadwood, South Dakota. Having forgone his usual seat with his back to the wall, Hickok was shot and killed while holding the now-famous "dead-man's hand," two pair made up of aces and eights—all black.

See also Remington's "A Monte Game in the Southern Ute Agency" (page 79).

BACCARA
c. 1925
Raoul Dufy
Born: 1879, Le Havre, France Died: 1953
black lead, 98 3/8" x 181"
© 1999 Artists Rights Society (ARS), New York/ADAGP, Paris
Whereabouts of work unknown

Raoul Dufy is surely one of the greatest artists ever to learn his craft in night school. The promise he exhibited in his evening drawing classes earned him a scholarship to the Ecole des Beaux-Arts in Paris. Initially, Dufy's artistic interests drew him to the Impressionists and Post-Impressionists. But following a few major exhibitions, he began to drift toward the Fauvist style. After meeting Braque and Matisse, Dufy again changed styles and embraced a rather severe form of Cubism. Later in his career he spent considerable time designing carpets, textiles, and ceramics. "Baccara" isn't Dufy's only piece relating to gambling; he also painted several scenes depicting horse racing and the racetrack culture in Europe.

Baccara is the Italian name for the game known as *chemin de fer* in France and baccarat in the United States. A banking game that worked its way from the 19th-century French casinos into illegal casinos in America in the early 1900s, baccarat made the big time when it became a hit in Las Vegas in the late '50s. Though an essentially mindless game devoid of strategy, baccarat has always been associated with high stakes and high society, as shown here.

60

A MISDEAL, Frederic Remington

BACCARA, Raoul Dufy

CASH FLOW

1997

Annie Lee

Born: 1935, Alabama, USA

acrylic on canvas embellished with glitter, 36" x 24"

Courtesy of the Artist and Annie Lee and Friends Art Gallery, Glenwood, Illinois

Born and raised on the south side of Chicago, Annie Lee is one of many famous artists whose craft was learned in night school, having earned her master's degree from Loyola University. She is primarily noted as a painter of African-American family life and women's family experiences; her artistic trademark is the characterization of her "Little People" who, though their faces are blank, exhibit great expression and enthusiasm through their actions. Along with being a successful artist whose work is recognized nationally and in Europe, Lee is also a thriving entrepreneur and gourmet cook. She currently resides in Henderson, Nevada.

Lee's painting incorporates many familiar elements of a modern casino: celebrant gamblers, cocktail waitresses, a change cart, a line at the ATM cash machine, even a Gambler's Anonymous sign at the cashier's cage. The emphasis on slot machines, several displaying the winning "777" symbols, reflects their dominance in today's gambling market. Poker, craps, blackjack, and a big six wheel are underemphasized in the background.

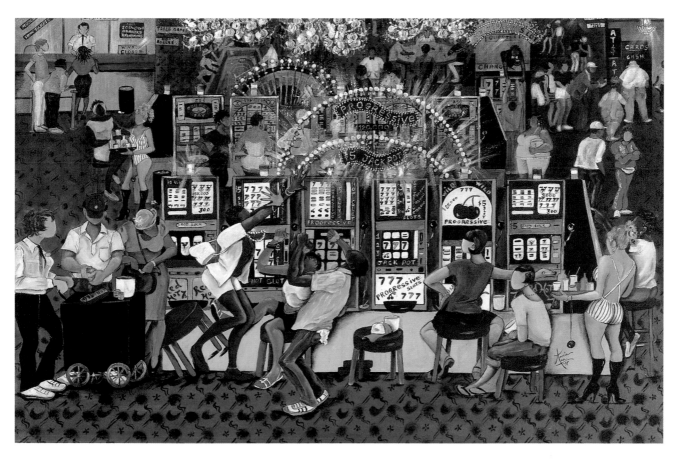

CASH FLOW, Annie Lee

CEZANNE STAMP

1963

Larry Rivers

Born: 1925, Bronx, New York, USA

oil on canvas, 42" x 54"

Hirshhorn Museum and Sculpture Garden, Smithsonian Institution,
gift of Joseph H. Hirshhorn, 1966/Licensed by VAGA, New York, New York

Larry Rivers was an accomplished jazz saxophonist who redirected his neural energies and his aesthetic sensibilities to become an equally accomplished painter. Indeed, Rivers has always been a multifaceted virtuoso. Following his studies at the Juilliard School of Music, he became interested in art when a jazz musician introduced him to a Georges Braque painting of a bass fiddle. Along with playing music and painting, Rivers once spent eight months writing poetry in Paris. He is also adept at sculpting in plastic and welded metal, and has been highly successful in designing sets for Broadway plays, e.g., Frank O'Hara's *Try, Try,* and Stravinsky's *Oedipus Rex* with the New York Philharmonic.

Rivers painted "Cézanne Stamp" as a tribute to Paul Cézanne's "The Card Players" (see page 9). Though the details, in both this and Cézanne's original, are too sketchy to pinpoint the game, for centuries the national card game of France has been a two-player game called *piquet.* Another two-man game called *belote* (a version of *klaberjass)* has gained popularity and is often played for stakes, but it hadn't yet been introduced at the time of Cézanne's original painting.

See also Rivers' "For the Magician of Lublin" (page 127).

CEZANNE STAMP, Larry Rivers

THE CARD PLAYERS

c. 1508

Lucas van Leyden

Born: 1494, Leiden, Holland Died: 1533

oil on panel, 21 ³/₄" x 24"

Another Flemish painter who was trained by his father was Lucas van Leyden. Although he was plagued by ill health most of his life, he enjoyed great popularity and was an accomplished artist by the tender age of 9, when he issued his first successful engraving. Van Leyden is credited with introducing significant innovations in Flemish genre painting. His use of half-length figures, as is seen in "The Card Players," increased the size and visibility of his subjects relative to the picture field. His themes rendered his scenes free of all moral connotations, which was unusual for that historical period. Van Leyden is respected as one of the most original artists in Northern Europe during his time.

Despite looking in every way like a modern-day poker game played with three cards, none of card history's likely ancestral candidates—e.g., post and pair, brag, *primero*—match up with van Leyden's 500-year-old gambling scene. There are three possibilities. First, this is an unknown variation of a known game. Second, van Leyden's brush captured something that writers' pens haven't. Third and most likely, the artist ignored details that would have identified the game. Regardless of the answer, one thing is clear: The "kibitzing" among players and spectators prevalent at poker gatherings today was also a part of gambling half a millennium ago.

See also van Leyden's "Card Players" (page 111).

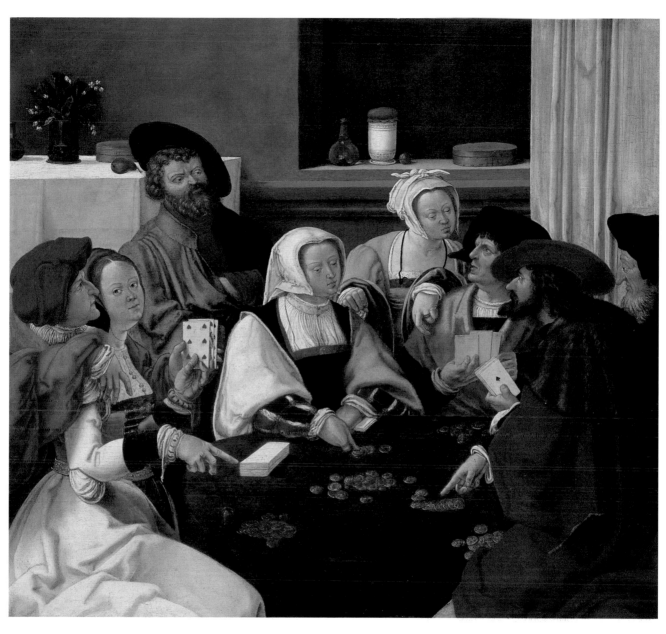

THE CARD PLAYERS, Lucas van Leyden

LETTER TO FRIEND THED

1908

Charles M. Russell

Born: 1864, Oak Hill, Missouri, USA Died: 1926

watercolor, pen, and ink, 9" x 6 ¹/₂"

C.M. Russell Museum, Great Falls, Montana

For biographical information about Charles M. Russell, see page 26.

Russell's allusions to the casino games of blackjack and monte notwithstanding, the men in this image appear to be playing a free-lance game of poker. Russell's phonetically written letter is a particularly telling barometer of the gambling climate of the day. While the level of acceptance of gambling in the United States rose and fell throughout the 19th century, it had mostly fallen from the 1870s till the turn of the century, except in the mining towns and outposts of the frontier West. Moreover, by the time of this painting, it was becoming increasingly difficult to find legal, organized gambling outside of Nevada (where it was permitted until a 21-year ban began in 1910). Still, in isolated situations, the trend toward a restrictive morality was bucked in the name of free enterprise, as Russell's references to the "lid being off," "wide-open games," and "the moralists" attest.

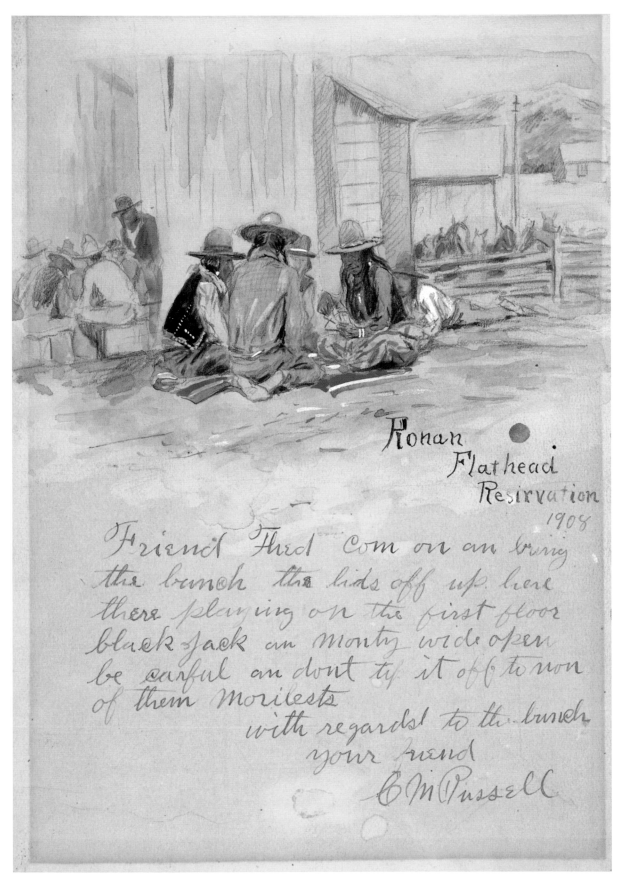

Ronan
Flathead
Resirvation
1908

Friend Thed Com on an bring
the bunch the lids off up here
there playing on the first floor
black jack an monty wide open
be carful an dont tip it off to non
of them morilests
with regards to the bunch
your friend
C M Russell

LETTER TO FRIEND THED, Charles M. Russell

THE CARD PLAYERS

c. 1850

William Sidney Mount

Born: 1807, Setauket, New York, USA Died: 1868

oil on panel, 19" x 24 3/4"

Reynolds House, Museum of American Art, Winston-Salem, North Carolina

For biographical information about William Sidney Mount, see page 50.

The coins on the table indicate a wagering game of some type, though probably not poker, given that the man on the right appears ready to play a card. Mount's scene, presumably set somewhere in his home state of New York, took place about 50 years before one of America's most infamous gambling towns, Saratoga Springs, would emerge nearby. Several small towns throughout the country—Steubenville, Ohio; Hot Springs, Arkansas; and Lexington, Kentucky—flourished due to illegal casinos in the early 20th century. Many of the workers from those casinos moved on to become legitimate dealers and bosses in early Las Vegas.

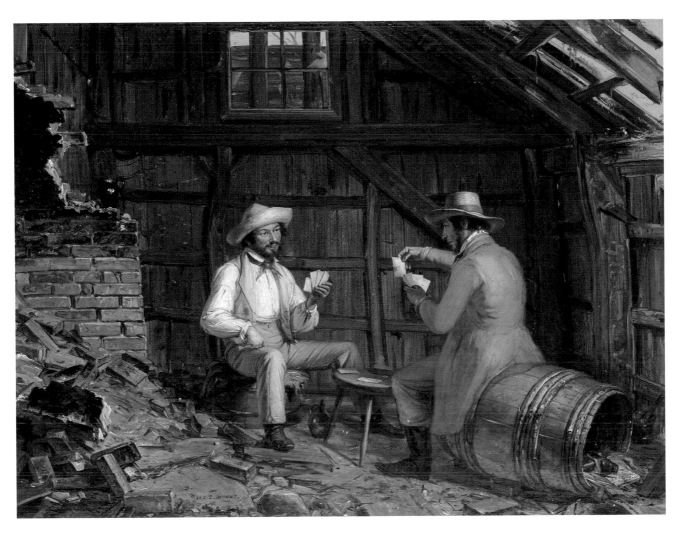

THE CARD PLAYERS, William Sidney Mount

THE CARDSHARPS

c. 1594

Caravaggio (Michelangelo Merisi)

Born: 1573, Caravaggio (Bergamo), Italy Died: 1610

oil on canvas, 37 $1/_{16}$" x 51 $9/_{16}$"

Kimbell Art Museum, Ft. Worth, Texas

Beginning his painting career in Milan where he first studied art, Caravaggio remained there until about age 20, when he left to seek work in Rome. Times were difficult at first, and to survive he often worked as an assistant to painters of little repute. His first paintings were primarily still lifes, during a time when the technique was just becoming accepted as an art form in Italy. Later, when he was commissioned to paint "The Calling" and "The Martyrdom of St. Mathew," Caravaggio initiated his own artistic revolution, which introduced his style of intense and dramatic realism. His paintings have been described as "strictly life-like," incorporating strong contrasts of light and shade. His unique style drew many followers who emulated his work.

Caravaggio apparently enjoyed various aspects of gambling. Later in his life, he was involved in an altercation in which he killed a man over an unpaid gambling debt. The title of this work describes its focus. Card cheaters have long been known as "sharps." The boy on the right will choose which of his "hold outs" to use after receiving a signal, known as an "office," from his accomplice. Caravaggio's documentation of card cheating predates even that of de La Tour (see page 5). Notice the backgammon board (with dice cup) in the lower left corner.

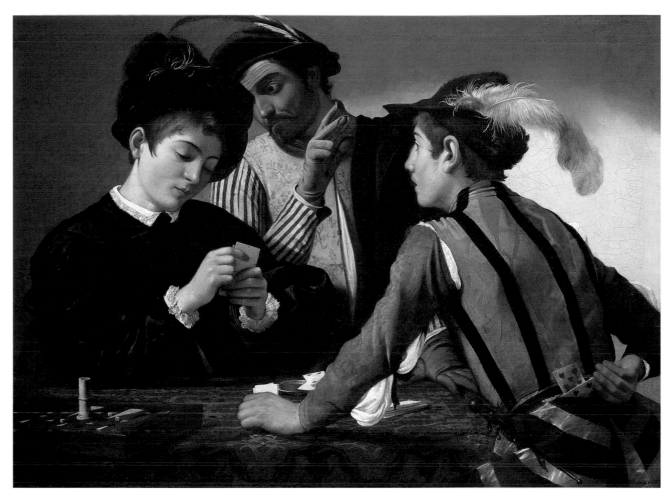

THE CARDSHARPS, Caravaggio

VEGAS CRAPS

1959

LeRoy Neiman

Born: 1927, St. Paul, Minnesota, USA

oil on canvas, 32" x 44"

Private collection

For biographical information about LeRoy Neiman, see page 24.

Neiman's "Vegas Craps" captures the game as it's played in the big casinos around the world. Fast, exciting, and social, casino craps represents the ultimate melding of gambling and entertainment. A casino crap game offers dozens of different wagers with escalating odds, ranging from a "line" bet ("pass" or "don't pass") with a casino advantage of 1.4 percent to the "proposition" bets, which top out at a casino edge of nearly 17 percent.

VEGAS CRAPS, LeRoy Neiman

Considered the greatest Spanish painter of the 18th century, Francisco Goya spent most of his life as the favorite artist of the royal Spanish court. Though his position among royalty was lucrative and made him famous throughout Europe, Goya became disillusioned with the corruption of King Charles IV and harshly criticized the king, the ruling class, and the church via a series of engravings that were immediately banned by the government. During Napoleon's invasion of Spain in the early 19th century, Goya was exposed to French art, and his painting style developed along Impressionistic lines. Goya, in turn, left an influential imprint on the French Impressionists, particularly Eduard Manet.

A form of the card game *hombre* was played three-handed during Goya's time. However, this scene, with the coins visible on the blanket, has the look of a poker game. A Spanish predecessor of poker was called *mus*. Another poker-like game, in which only three of four players were active at one time, was *golfo*. On close inspection, the distinctively illustrated Spanish cards are apparent (40-card deck).

THE CARD PLAYERS, Francisco Goya

THROW OF DICE NO. 17
1963
Robert Motherwell
Born: 1915, Aberdeen, Washington, USA Died: 1991
oil on canvas, 72 1/8" x 48 1/8"
Private collection © 1999 Dedalus Foundation Inc./Licensed by VAGA, New York, New York

Robert Motherwell spent most of his early life in San Francisco, where he was awarded a fellowship at the prestigious Otis Art Institute at the age of 11. His initial interest was in Surrealism; however, while working in New York, he became associated with the Abstract Expressionist movement. In 1943, Motherwell was invited, along with Jackson Pollock, to produce collages for Peggy Guggenheim's "Art of This Century" exhibit. From that time forward, Robert Motherwell's work with brightly colored collages represented the major part of his artistic output. He was among the last, and most famous, of the Abstract Expressionist group.

Though Motherwell's image conveys no solid information about gambling, the title's reference to dice—similar to the title references of Jean Arp (see page 29) and Hans Haem (see page 137)—suggests a concession to an influence of randomness in his technique.

A MONTE GAME IN THE SOUTHERN UTE AGENCY
1901
Frederic Remington
Born: 1861, Upstate New York, USA Died: 1909
oil on canvas, black and white, 27" x 40"
Courtesy of Frederic Remington Art Museum, Ogdensburg, New York

For biographical information about Frederic Remington, see page 60.

Monte was a popular American "banking game" in the saloons and casinos of the American West, and enjoyed some popularity in illegal gambling clubs during the 20th century. Also called Spanish monte or monte bank, the game requires no special apparatus, but uses a 40-card Spanish deck devoid of eights, nines, and tens. The monte being dealt in Remington's painting should not be confused with three-card monte, a con game prevalent on the streets of big cities, both at the turn of the century and today.

THROW OF DICE NO. 17, Robert Motherwell

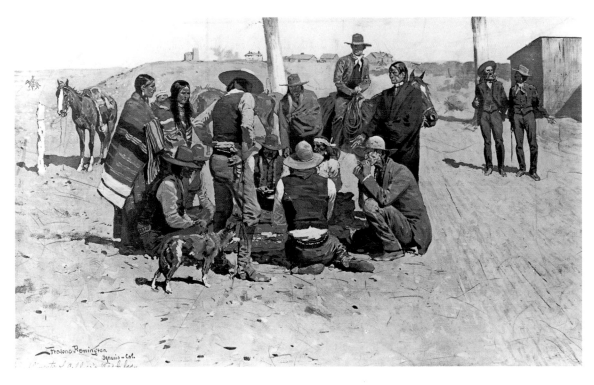

A MONTE GAME IN THE SOUTHERN UTE AGENCY, Frederic Remington

POSSIBLE FLUSH

1996

Ann O'Lear

Born: 1953, Rhode Island, USA

mixed media, 22" x 15"

Courtesy of the Artist, Reno, Nevada © 1996

Ann O'Lear found her artistic niche in the casinos of Nevada and has thrived in her work ever since. Born on the East Coast, O'Lear migrated west with her family; she was raised in the Mohave Desert and educated in Los Angeles. She got her first big opportunity to show her stuff as a sketch artist at Amarillo Slim's Super Bowl of Poker in 1987. O'Lear lives and creates in the Reno-Tahoe area of Northern Nevada.

O'Lear's gambler is playing a version of poker known as seven-card stud. In this game, two cards are dealt face-down, followed by four more cards face-up (with betting intervals in between), then a final card face-down. In casino and cardroom games, the house dealer calls out potential good hands ("pairs and possibles") after each card is dealt. In this case, the four hearts "on the board" would prompt the call: "possible flush."

MUCK

1996

mixed media on paper, 22" x 15"

Courtesy of the Artist, Reno, Nevada © 1996

In this image, O'Lear portrays a man throwing his poker hand into the pile of discards, known as the "muck," signifying that he's dropping out of the hand, or "folding."

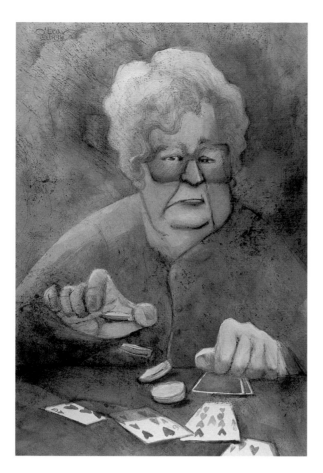

POSSIBLE FLUSH, Ann O'Lear

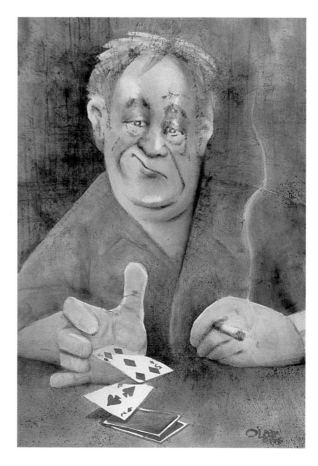

MUCK, Ann O'Lear

BOY GAMBLING WITH THE DEVIL
1974
Paula Rego
Born: 1935, Lisbon, Portugal
gouache on paper, 70 cm x 50 cm
Whereabouts of work unknown

An only child, Paula Rego was separated from her parents a year after she was born and was raised by her grandparents, whom she loved dearly, and an old aunt, whom she disliked intensely. The artist attributes some of her rebellious work to the inward struggle of defiance against her aunt. Early in her artistic career, Rego was affected and motivated by the work of Jean Dubuffet, whose paintings she saw at an exhibition in London.

Rego's theme is gambling for the ultimate stake: a human soul. The prospect has fascinated artists of many disciplines for centuries, from Goethe's poem *Faust,* to the Charlie Daniels song "The Devil Came to Georgia," about a boy who challenges the devil for a golden fiddle. Notice the ancillary gambling images: the spades and diamonds on the cloaks and the miniature demons gambling in the lower right corner.

CARD GAME
1967
Raymond Johnson
watercolor on paper, 24" x 30"
Heard Museum, Phoenix, Arizona

"Ne-Cha-He" is the Navajo name of Raymond Johnson, a painter and illustrator of Navajo life. Johnson favored images of tribal hunting, marriage rites, and dancers. Most of his paintings were executed in watercolor. "Card Game" is a typical portrayal of tribal gambling.

Cards was just one of the many games Native Americans used for gambling. A famous gambling game attributed to the Navajo is the moccasin game. According to legend, the moccasin game was first played by the gods to settle an argument over whether the world should exist in dark or light. The gods transformed themselves into two groups of animals to play. A piece of turquoise was hidden in one of the moccasins belonging to one group, while the other group tried to guess which moccasin held the stone. After playing all day with neither side gaining a point advantage, it was agreed that half of a day would be dark and half would be light. American Indians continue to play the moccasin game in this same fashion.

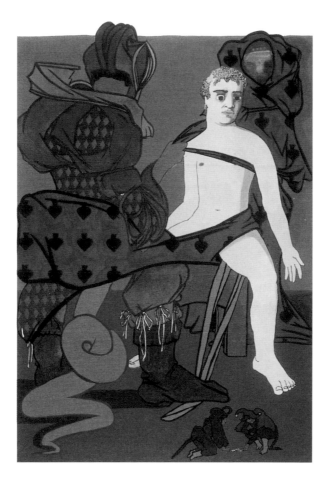

BOY GAMBLING WITH THE DEVIL, Paula Rego

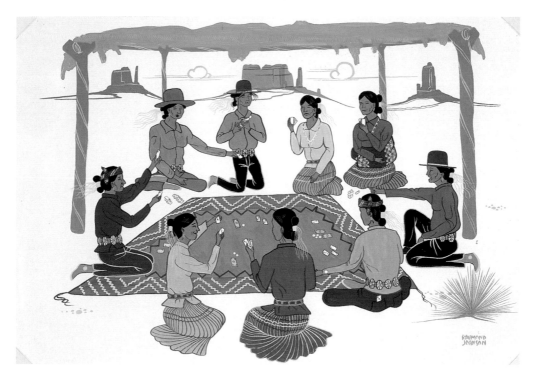

CARD GAME, Raymond Johnson

THE GAMBLE

1968

Romare Bearden

Born: 1912, Charlotte, North Carolina, USA Died: 1988

collage, mixed media on paper, 22" x 29 3/4"

© Romare Bearden Foundation/Licensed by VAGA, New York, New York

Although Romare Bearden was born in North Carolina, he grew up and spent much of his life in Harlem. His father worked for the city of New York, and his mother wrote for the *Chicago Defender* as its New York correspondent. Bearden was inspired by his mother's work in the media and began drawing political cartoons for the *Baltimore Afro-American*. Strongly influenced by Stuart Davis, one of the masters of American Cubism, Bearden used collage to intermingle Cubism with African tribal art to portray life in black America.

"The Gamble" reflects a scene, typical not just in Harlem but throughout many areas of America—rural, suburban, and urban—where living-room card games are a prominent form of entertainment. In this image, the duplication of jacks of the same suit suggests that the game is pinochle, which is played with two 24-card decks of nines through aces. The three-handed version is called auction pinochle. In its many variations, pinochle is well-suited to gambling and has been played as a gambling game dating back to its direct relative, *bezique.*

THE GAMBLE, Romare Bearden

RUIN OF A FAMILY BY GAMBLING
19th century
Adolph Echtler
oil on canvas, 150 cm x 170 cm
Whereabouts of work unknown

Biographical information about Adolph Echtler could not be obtained.

While the apparent anti-gambling compositions of Odilon Redon (see page 57) and Grace Hartigan (see page 109) are subject to interpretation, there can be no doubt of Echtler's intent in this work. From his title to his portrayal, the artist renders a scathing condemnation of gambling addiction. A wife pleads and children cry, but the game continues without interruption. Echtler issued his gripping anti-gambling message nearly a century before the founding of Gamblers Anonymous in 1957.

SUNDAY AFTERNOON
1930
George Grosz
Born: 1893, Berlin, Germany Died: 1959
pencil, brush and India ink, 59.5 cm x 46 cm
© Estate of George Grosz/Licensed by VAGA, New York, New York

Deemed one of the fathers of classical German Expressionism, George Grosz is acclaimed for executing satirical expressions of the period's socio-political scene, much in the fashion of the politics-through-art of Francisco Goya and Honoré Daumier. Early in his career, Grosz was influenced by the Dada movement and became a force in the left wing of the New Objectivism group. Though he is often reported as being an American painter, he was born in Berlin, Germany and later returned there where he died in 1959. In "Sunday Afternoon," Grosz assembles some of Nazi Germany's most prominent social and political personages, some of whom played significant roles in propelling Adolph Hitler to power. Portrayed are (clockwise from top center): Rosa Valetti, Otto Meissner, Hjalmar Schacht, Franz von Papen, Celly de Rheidt, Kurt von Schleicher, unknown, and Gustav Krupp von Bohlen und Hallbach.

The game shown here is probably baccarat, distinctive for the "shoe" in the foreground, which is always used in this game to hold and dispense the cards. The two cards in the center of the table appear to be the starting hand of the "banker."

RUIN OF A FAMILY BY GAMBLING, Adolph Echtler

SUNDAY AFTERNOON, George Grosz

BETTING MONEY ON THE COCKFIGHT

1990

Francis X. Pavy

Born: 1954, Lafayette, Louisiana, USA

oil on canvas, 37" x 37"

Morris Museum of Art, Augusta, Georgia

Biographical information about Francis X. Pavy could not be obtained.

In "Betting Money on the Cockfight," Pavy incorporates symbols of all the vices often seen in the gambling arena—booze, sex, violence, and greed—but in abstract form. In America, cockfighting was an enormous betting draw toward the end of the 1800s, especially in the South. While wagering on the contests is officially prohibited today, cockfighting itself remains legal in a handful of states.

BETTING MONEY ON THE COCKFIGHT, Francis X. Pavy

An artist-muralist born in Italy, Carlo Marchiori received a classical European art education. Later he moved to California, where he currently resides and is referred to in local circles as the "Maestro D'Arte." Marchiori excels in several media, including ceramics, wood sculpture, watercolor, and oil. His art consistently embodies meticulous workmanship, technical excellence, and wit, and his strong sense of history infuses his work with a sense of timelessness.

This image portrays gamblers during Carnaval in late 18th-century Venice. A Venetian gambling house was known as a *ridotto,* which means "reduced price." The tradition continues today, as casinos offer bargain prices on food and lodging to draw gamblers.

GAMBLING AT THE RIDOTTO, Carlo Marchiori

Biographical information about Alexander Atteniese could not be obtained.

Close inspection confirms that the objects being dropped are, indeed, small bones. These early dice-like instruments are known as "astragals," taken from the Greek *astragalos,* which is a turning joint, e.g., an anklebone or a knucklebone. The knucklebones of sheep or goats seem to have been favored in ancient times. These forerunners of cubed dice were usually less versatile than their six-sided descendants, often providing just two possible outcomes.

Fascinated by the work of Caravaggio, Theodoor Rombouts spent much of his time perfecting his own approach along those lines after completing his art education in Antwerp. As much as he tried to stay true to this style, however, Rombouts eventually succumbed to the painting technique that emanated from his earlier roots: the then-popular "Flemish Baroque" school.

The great gambling game of backgammon, depending on how loose the criteria, can be linked to predecessors as far back as 2,000 years before the Common Era. More defensible ancestors include the Roman *duodecim scripta* and the Persian *nard.* The game as it's known today seems to have shown up, under various names, in the 13th century, and specifically as backgammon, which means "the back game," not long before the date of this painting. Today, backgammon ranks as one of the world's most recognizable and commonly played board games.

KNUCKLEBONE PLAYERS, Alexander Atteniese

THE BACKGAMMON PLAYERS, Theodoor Rombouts

93

THE GREEN TABLE

1941

Jacob Lawrence

Born: 1917, Atlantic City, New Jersey, USA

gouache on paper, 22 1/2" x 16 1/2"

Private collection, New York, courtesy of the Artist

For biographical information about Jacob Lawrence, see page 48.

An intermediate step between private and casino craps was the illegal backroom dice game, prominent in America throughout most of the 20th century. This hybrid of craps had "operators," who made money either by booking bets at less than true odds or by charging a fee ("vigorish") on certain wagers. Lawrence's fascination with pool (see "The Cue and the Ball," page 49, and "The Pool Game," page 141) ties in here; pool tables were often converted into makeshift crap tables because of their felt surfaces. However, Lawrence's attention to detail appears a bit lax: The "do" and "don't" betting spaces are reversed on each end of the table; the ten is missing from the "field" (which also has numbers arranged irregularly); and several of the dice in the dangling "tray" are misspotted.

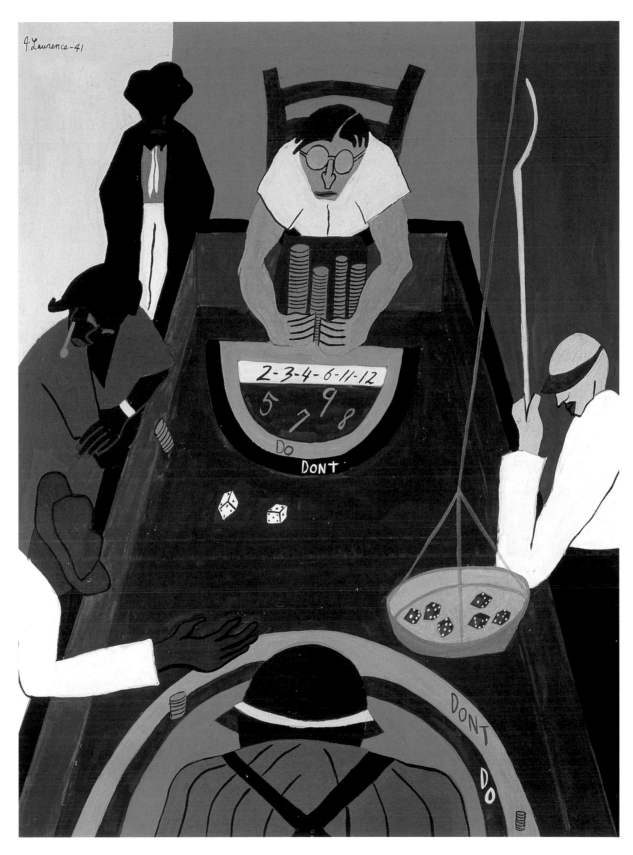

THE GREEN TABLE, Jacob Lawrence

GAMBLER'S CABINET

1976

Audrey Flack

Born: 1931, New York, New York, USA

oil over acrylic on canvas, 83" x 78"

Courtesy of Louis K. Meisel Gallery, New York, New York

Often labeled a Photorealist, Audrey Flack is actually a multitalented artist who has worked in a variety of media, such as sculpting, photography, and drafting. She studied at Yale University and the Institute of Fine Arts, New York University; her initial influence was Abstract Expressionism. Over the years Flack has gained esteem in the art world for her Photorealist paintings, portraying feminist still-life scenes, including many images that exhibit gambling paraphernalia. Among her most popular works in the gambling genre are "Royal Flush" and this painting, "Gambler's Cabinet."

The items displayed in "Gambler's Cabinet" include a deck of cards, a pair of dice, and two silver dollars. Silver dollars, which were produced in mass quantities following the many silver strikes of the Old West, were used in casinos for slot machines and table games until the relatively recent introduction of chips and slot tokens.

GAMBLER'S CABINET, Audrey Flack

THE CRAPSHOOTER

1941

Julien Binford

Born: 1908, Fine Creek Mills, Virginia, USA

oil on canvas, 36" x 74"

Private collection, courtesy of D.C. Moore Gallery, New York, New York

As a pre-medical student at Emory University in Georgia, Julien Binford sketched such realistic anatomical renderings that he was encouraged to study at the Art Institute of Chicago. During World War II, he was artist correspondent for *Life* magazine, and many of his World War II paintings still hang on the walls of the Pentagon in Washington, D.C. Binford lives and works in a converted musket factory in Virginia, where he paints his neighbors at work and play.

This is another depiction of a makeshift crap game in progress. Such games are often initiated by "crap hustlers," who aren't necessarily dice cheats. Most hustlers simply have a superior grasp of dice odds and derive their advantage by finding opponents who will accept propositions at less than true payoffs. Dice hustlers exist today, plying their skills at private parties, as well as at charity gambling events, where there is no "banker."

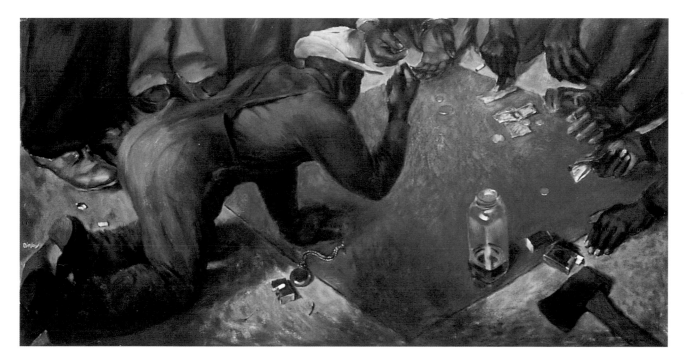

THE CRAPSHOOTER, Julien Binford

ROLL-A-TOP

1981

Charles Bell

Born: 1935, Tulsa, Oklahoma, USA

oil on canvas, 32 ¹/₂" x 40"

FIVE CENT SLOT

1990

aquatint etching on paper, 29 ¹/₂" x 38 ¹/₂"

Both images courtesy of Louis K. Meisel Gallery, New York, New York

Charles Bell began his artistic career in California during the 1960s and gravitated toward painting images of toys and other objects of childhood play. As a leading painter in the Photorealist style, Bell made a name for himself working from photographs to create two popular series: the "Gumball Machines" and the "Pinball Machines." He later demonstrated an interest in gambling when he produced "Roll-A-Top" and "Five Cent Slot," two images depicting slot machines.

The slot machine, the most efficient casino gambling game ever devised, was invented in San Francisco in the late 1890s by Charlie Fey. Slot machines were called "one-armed bandits" for the single handle that activated the machine, and "fruit machines" in Europe for the pictures of fruit used as symbols on the reels. The early slots, as portrayed here, were mechanical and had limited payout possibilities, as evidenced by the "pay table" in "Roll-A-Top." Electro-mechanical slots were introduced about a half-century later, followed by electronic slots, then by the computerized slots that are dominant today. Each generation added more enhancements. The current combination of computer and video technologies has opened up a vast and versatile new world of slot machines, and telecommunications has enabled the linking of machines between casinos to produce multimillion-dollar jackpots. Today, slots occupy more than 50 percent of a typical casino floor and attract more players than all of the other casino games combined.

ROL-A-TOP, Charles Bell

FIVE CENT SLOT, Charles Bell

THE BELCH OF THE JACKPOT

1996

Lorna Greene

Born: 1937, Newark, New Jersey, USA

oil on paper, 24" x 36"

Courtesy of the Artist, Las Vegas, Nevada

A multifaceted painter, writer-poet, actress, and sculptor, Lorna Greene was raised in New York and studied there. In recent years, she has worked and created in Los Angeles and Las Vegas.

The undertones of desperation in Greene's painting are recognizable at a glance by most gamblers. However, her accompanying poem, which appears in part on the painting, enhances the image's dramatic impact.

The Belch of the Jackpot

by Lorna Greene

She puts the nickel in to win
The tinkle of the coins begin
a metabolic change within and
trembling with this mad malaise she plays.
The world outside can wait for days.

She listens, looks, she rapes, blasphemes
"I love you, hate you, damn machine …"
She rants and raves, she struts a style
the monstrous "Hyde," the "Jeckyl" smile
Till nothing parallels this scene
a round and round orgasmic dream.

Full dress in fantasy she squeals
"Who was it said, this isn't real?
Now, open up that magic door, I want to hear
big jackpot roar."

The box is bored with her caress
"She falters, falls, this thing of flesh …"

It coos and spits the blinding rays
"The winner gets, the loser pays."
Then, quiet, silent as a tomb, the door is closed
There is no more.

Wild thoughts to steal her husband's pay
"Oh God, I'm cursed, Why do I play
this game with death
I will go home, I'll beg, I'll crawl …"
She makes amends, buys gifts for all.

But soon a storm will gather in her brain
Loud Baroque trumpets blast …
Her footsteps turning back again she moves
to voices only she can hear.

The tinkle of the coins begin
a metabolic change within
And trembling with this mad malaise
She plays.

THE BELCH OF THE JACKPOT, Lorna Greene

LUCK OF THE DRAW
1995
Suz Brna

Born: 1958, Milwaukee, Wisconsin, USA

acrylic on canvas, 30" x 40"

Courtesy of the Artist, Las Vegas, Nevada © 1995

Suz Brna's talented parents (her mother was a fashion designer, model, painter, potter, and musician; her father was a writer and a poet) provided her with a head start on her artistic education. Early in her career, Brna patterned her painting style after the German Expressionists and the French Impressionists, especially Toulouse-Lautrec. During the late '90s, she demonstrated her considerable sculpting skills when she created 40 original pieces for the Venetian Hotel and Casino on the Las Vegas Strip. Brna lives and works in Las Vegas, a city she compares with late 18th-century Paris: "an avant-garde surrealistic environment that lends itself well to artistic expression."

The game played here is twenty-one, which can be identified by the casino surroundings and distinctive betting square on the twenty-one table. The origins of this most popular of casino games are somewhat obscure; it's claimed to some degree by the Spanish (invoking their version of a game called thirty-one) and the Italians (citing their seven and a half). The French seem to have the most plausible claim, given their well-known *vingt-et-un* (or *vingt-un),* which may have been mispronounced to derive the British name for the game: pontoon. Twenty-one's American nickname, blackjack, is said to have developed at Midwestern racetracks, where a $5 bonus was paid for a two-card count of 21 when one card was a jack of spades or clubs. Blackjack made its first appearance in Nevada casinos as soon as they became legal in 1931, and within 15 years it replaced craps as the most popular banking game.

See also Brna's "Pay Day" (page 185).

THE DANCE OF DEATH IS FORBIDDEN
1996
Zara Kriegstein

Born: 1952, West Berlin, Germany

acrylic on canvas, 60" x 76"

Courtesy of the Artist, Santa Fe, New Mexico

For biographical information about Zara Kriegstein, see page 40.

This image employs cards and money as references to gambling, a detail that was fully intended by the artist: "Today's societal emphasis on security, morality, and religion has the effect of suppressing mankind's basic eternal characteristics. This is why, whenever allowed, thousands flock to places where they can experience, once again, that life is a gamble. Taking a risk stirs our blood; to experience the so-called 'forbidden' gives us excitement. Indulgence in food, masquerades, and gambling brings us the relief from the personality masks that society forces us all to wear."

LUCK OF THE DRAW, Suz Brna

THE DANCE OF DEATH IS FORBIDDEN, Zara Kriegstein

MONTE CARLO

1890

Louis Collisz

oil on canvas

Courtesy of Main Street Station Hotel and Casino, Las Vegas, Nevada/On public display

Biographical information about Louis Collisz could not be obtained.

This scene conveys a sense of both the popularity of roulette and the enormity of the European gambling halls of the 19th century. While gambling lore and a popular song celebrate the exploits of "the man who broke the bank at Monte Carlo," the reality is less spectacular than the legend, since a roulette "bank" in Monte Carlo consisted only of the capital on hand for a single table, not for the entire casino. The largest verifiable win on a single spin of a roulette wheel occurred in 1994 at Binion's Horseshoe in Las Vegas. A tuxedo-clad computer programmer from London, England, arranged to wager $220,000 on one coup. After a practice spin that landed in the zero slot, the man placed his bet on red and watched the ball drop into red seven. The "punter" collected his winnings and left.

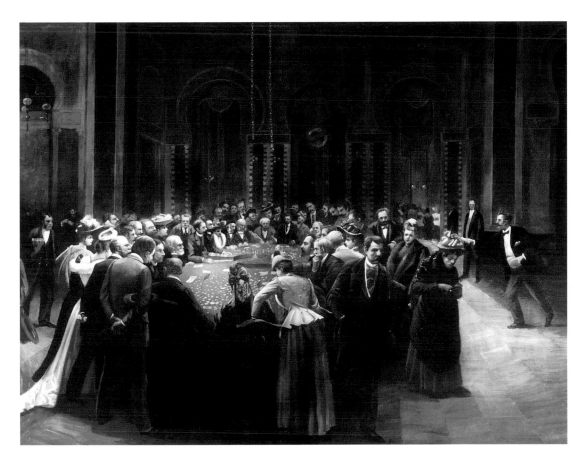

MONTE CARLO, Louis Collisz

CASINO

1987

Grace Hartigan

Born: 1922, Newark, New Jersey, USA

oil on canvas, 73" x 79"

Courtesy of ACA Gallery, New York, New York

Grace Hartigan's painting technique was initially influenced by Henri Matisse's Modern style, then later by Jackson Pollock's drip paintings. While active in the New York School movement, she developed her own Abstract Expressionist style and became a contemporary of such Abstract Expressionists as Pollock, Willem de Kooning, Helen Frankenthaler, and Mark Rothko. Later in life, Hartigan began to visit some of the meccas of pleasure, spending time in Florida, California, and Atlantic City, where she explored the world of gambling.

"Casino," one of Hartigan's most Expressionistic works, indicates a disapproval of casino gambling. Her depiction of players with dark eyes and somber faces crowded around a roulette table is taken by some to be an anti-gambling declaration. It is, at least, an acknowledgment of the despair that goes hand in hand with losing.

See also Hartigan's "Renaissance Card Game" (page 191).

CASINO, Grace Hartigan

CARD PLAYERS
c. 1511
Lucas van Leyden
Born: 1494, Leiden, Holland Died 1533
oil on panel, 13 ³/₈" x 18 ³/₄"
Whereabouts of work unknown

For biographical information about Lucas van Leyden, see page 66.

The game portrayed here is the apparent three-card variation of poker discussed in connection with van Leyden's earlier work, "The Card Players" (see page 67). Note the longer cards of the day. This size, coupled with the wide separation between "pips" and the absence of corner "indices," necessitated that cards be held with two hands to facilitate identification. When the first cards with indices were introduced more than three centuries later, they were called "squeezers" for the manner in which they could be held and surveyed more conveniently.

THE CARD PLAYERS
1846
Richard Caton Woodville
Born: 1825, Baltimore, Maryland, USA Died: 1855
oil on canvas, 47 cm x 63.5 cm
The Detroit Institute of Arts, gift of Dexter M. Ferry Jr.

Richard Caton Woodville was born to a prominent Maryland family that could afford to give him the best art education available. He attended St. Mary's College, where he was tutored by the famed painter Alfred Jacob Miller. From there, Woodville went on to study at the prestigious Dusseldorf Academy in Germany and was one of Carl Ferdinand Sohn's private students. Woodville spent most of his short life in Paris and London. Although his visits to his home country were infrequent, his art—especially his engraving work—was very popular in the United States.

The game portrayed here is indistinguishable, but the look of English gentlemen with servant at the ready and the time period evoke the two-handed game of cribbage. Played with a distinctive pegboard for score tallying, cribbage dates all the way back to the 16th century, when it was called noddy. Cribbage is definitely a gambling game, which helps account for its extended and ongoing popularity in British pubs and American clubs.

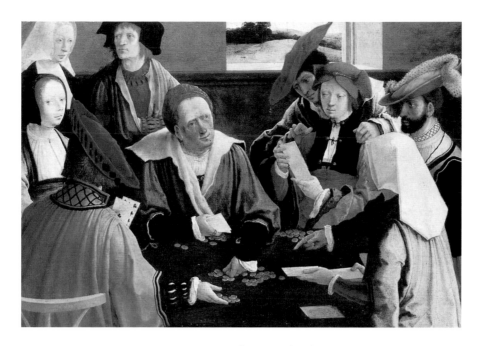

CARD PLAYERS, Lucas van Leyden

THE CARD PLAYERS, Richard Caton Woodville

RAFFLING FOR THE GOOSE

1837

William Sidney Mount

Born: 1807, Setauket, New York, USA Died: 1868

oil on wood, 17" x 23 ¹/₈"

The Metropolitan Museum of Art, gift of John D. Crimmins, 1897

For biographical information about William Sidney Mount, see page 50.

Raffles are nothing more than small-scale lotteries where the prizes, instead of money, are usually goods or services. The mechanics of the operator's edge in a raffle are simple: take in more money through the sale of tickets than it costs to provide the prize. For example, if the goose in this 19th-century raffle cost 50 cents, the operator had to sell at least six tickets at 10 cents apiece for his game to have been profitable.

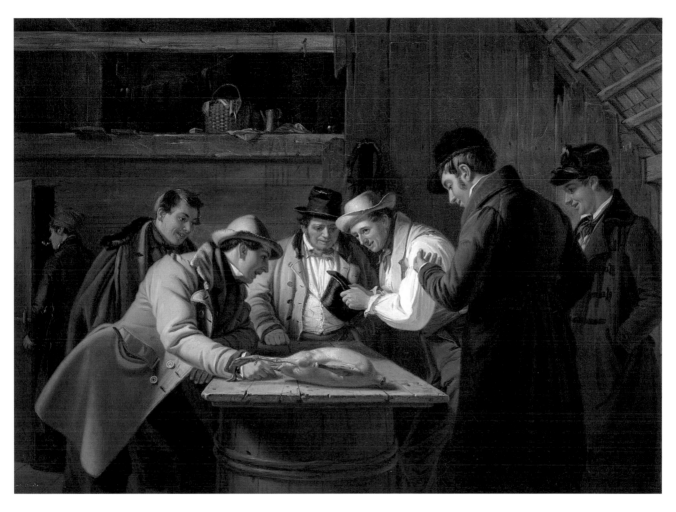

RAFFLING FOR THE GOOSE, William Sidney Mount

Protest art, an outgrowth of the German Expressionist movement, was led by George Grosz and Otto Dix, and supported but followed more distantly by Max Beckmann. Although profoundly influenced by classical Cubism, Beckmann's style is exemplified by the use of brilliant colors and heavy lines, charging his paintings with strong emotion and intense energy. "Baccarat" was painted in Amsterdam after Beckmann was forced to escape Hitler's Nazi regime, which had labeled him as one of the "degenerate" artists of Germany.

In baccarat, players have three betting options: "banker," "player," and "tie." The symbolism intended by the man sitting at the table with a sword in his hand is open to innumerable interpretations. However, using the sword's edges as a metaphor for the casino edge, the banker side carves the house a 1.06 percent slice of the money bet; the player side, a 1.24 percent share; and the sword's point, representing tie, a whopping 14.4 percent chunk. Since the woman handling the cards isn't in control of the dealing "shoe," she is probably playing the hand of the "player."

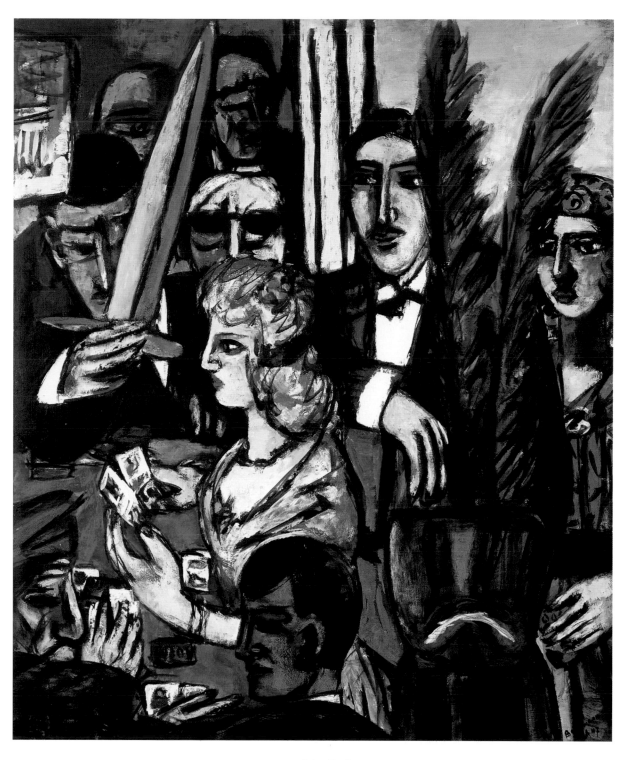

BACCARAT, Max Beckmann

A CALL — IN ARIZONA

1895

A.C. Radwood

color lithograph, 11 ⁵/₈" x 18 ¹/₄"

The Metropolitan Museum of Art,
the Elisha Whittelsey Collection, the Elisha Whittelsey Fund, 1948

Biographical information about A.C. Radwood could not be obtained.

The cards in hand, the pot of chips in the center of the table, and the painting's name suggest that this argument has developed over a game of poker. Cheating is evident, as there are two aces of hearts present—one in the hand of the tuxedoed player and another on the floor. Note the Union soldier seated on the left. The American Civil War (1861–1865) marked a turning point for gambling in the United States. After the war, the preponderant action moved from riverboats in the Midwest to the saloons and casinos of hundreds of mining boomtowns around the West.

A CALL — IN ARIZONA, A.C. Radwood

NEIMAN'S GOLDEN NUGGET

1988

LeRoy Neiman

Born: 1927, St. Paul, Minnesota, USA

oil on canvas

Collection of the Golden Nugget Casino, Las Vegas, Nevada/On public display

For biographical information about LeRoy Neiman, see page 24.

"Neiman's Golden Nugget" is early evidence of casino magnate Steve Wynn's proclivity for art patronage. Wynn commissioned this piece years before he built Bellagio in Las Vegas, which features a museum displaying world-class art. This image of the inside of the Golden Nugget casino depicts the high-stakes blackjack and baccarat pit, along with a crap game on the right. In the lower left corner, entertainers Kenny Rogers and Paul Anka talk to a seated Wynn. Neiman painted himself into the scene; he's seated at the far left corner of the baccarat table.

NEIMAN'S GOLDEN NUGGET, LeRoy Neiman

THE COCKFIGHT

1759

William Hogarth

Born: 1697, England Died: 1764

etching and engraving, 29.5 cm x 37.5 cm

Courtesy of Haley & Steele, Boston, Massachusetts

William Hogarth was among the most prominent of England's 18th-century artists. As a young man, he learned the craft of engraving in London. His art focused on portraying the moralities, virtues, and vices of London's middle class, with which he was intimately familiar. His first paintings—which later became etchings and engravings—were included in his popular series, "The Harlot's Progress."

Cockfighting has been traced as far back as several hundred years before the Common Era, predating the Roman Empire and even the golden age of Greece. It worked its way through Europe to become a favorite pastime of English nobility from the 16th century through the 19th century, when it was finally banned. Hogarth's scene depicts a commingling of noblemen, bourgeois gentlemen, and common street punters ringing a cockfighting pit. Bets were made and accepted at constantly changing "prices" (odds) throughout the duration of a match, known as a "main." Cockfighting is one of several animal fighting contests—including dogfighting and bearbaiting—that have been used for wagering throughout history.

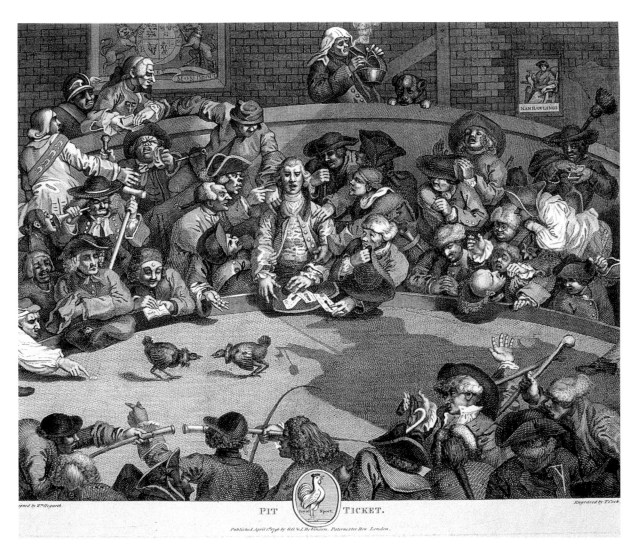

THE COCKFIGHT, William Hogarth

CARD GAME
1942
Isabel Bishop

Born: 1902, Cincinnati, Ohio, USA Died: 1988

watercolor, pencil, charcoal, and pen and ink, 36.6 cm x 58.4 cm

Brooklyn Museum of Art, Henry L. Batterman Fund

Isabel Bishop studied at the Wickes Art School in Detroit, as well as at the School of Applied Design and the Art Students' League, both in New York City (she also taught at the Art Students' League later in her career). Bishop was considered primarily a painter and etcher, whose early style was reminiscent of the old Dutch Masters; her later work was characteristic of 17th-century Italian painting. She spent most of her professional life living and painting in New York City, where she was associated with the Ashcan School.

Given the time period and setting, the three-player game portrayed here could be hearts. A great gambling game that adapts well to varying numbers of players, hearts is known for the single card that must be avoided during play: the queen of spades, which is also called black lady, black widow, black Maria, and the bitch.

CARD GAME, Isabel Bishop

ARTS OF THE WEST

1932

Thomas Hart Benton

Born: 1889, Neosho, Missouri, USA Died: 1975

tempera with oil glaze, 8' x 13'

New Britain Museum of American Art, Connecticut, Harriet Russell Stanley Fund
© T.H. Benton and R.P. Benton Testamentary Trusts/Licensed by VAGA, New York, New York

For biographical information about Thomas Hart Benton, see page 2.

The inextricable linking of America's Old West and poker is evident in "Arts of the West"; in the painting's display of classic western images, the game of five-card draw poker is most prominent. While "draw," as it was called, and faro were the most popular gambling games of the period, others included blackjack, monte, chuck-a-luck, keno, roulette, seven-up (a variation of all fours or pitch), cassino (from the Italian game of *scopa),* and a shell game of dubious repute known as thimble big.

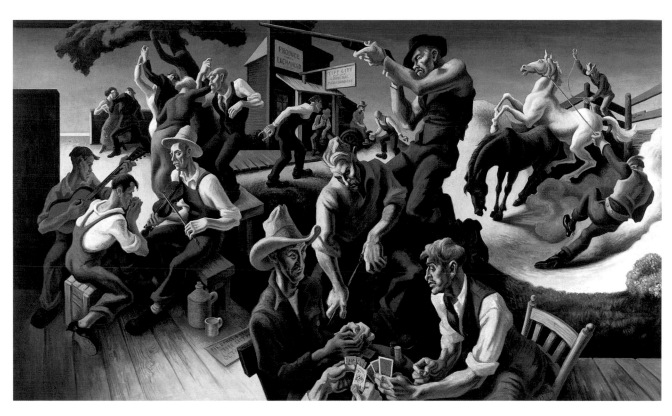

ARTS OF THE WEST, Thomas Hart Benton

For biographical information about Larry Rivers, see page 64.

The connection between gambling and magic runs deep. Beyond the obvious common denominator, cards, the disciplines dovetail in the areas of psychology, logic, and mathematics. Of course, the card "mechanic" and the sleight-of-hand magician ply the same trade. But also similar to magicians, the best gamblers—blackjack card counters and successful poker players—must be adept at understanding and applying the principles of "confidence."

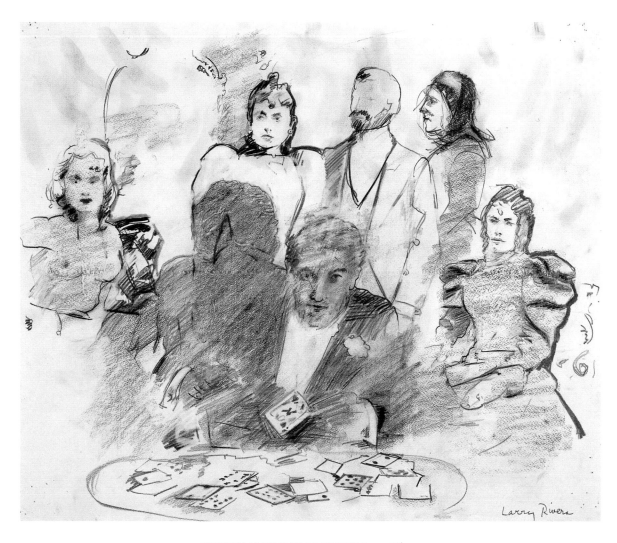

FOR THE MAGICIAN OF LUBLIN, Larry Rivers

CARD PLAYERS

1916

Theo Van Doesburg

Born: 1883 Died: 1931

tempera on canvas, 46 ¹/₂" x 58"

CARD PLAYERS

1917

45 ¹/₈" x 41 ³/₄"

Theo Van Doesburg, together with Piet Mondrian, is credited with founding the De Stijl art movement. Deeply influenced by Cubism and Wassily Kandinsky's Free Abstraction painting style, Van Doesburg began to develop his own technique after seeing Cézanne's "Card Players." Cézanne's influence led to Van Doesburg's composition of the first "Card Players" (top image) followed by a more mathematically based work with the same title (bottom image). Van Doesburg broke away from the De Stijl movement during the 1920s, subsequently drifting toward a Dada style.

Van Doesburg's "Card Players" might be playing a form of euchre, a game that became popular in the American Northeast and Midwest after being introduced by the Pennsylvania Dutch. Euchre is essentially a partnership game, though one player may choose to play "alone," which could account for the single player (a partner) standing out in the top image. Also, the game uses cards of lower ranks, such as those in the painting's corners, for keeping score. Euchre, as well as the related game *hasenpfeffer (hasse),* is commonly played for money. A forerunner, *écarté,* was well-established as a gambling game in 19th-century French casinos.

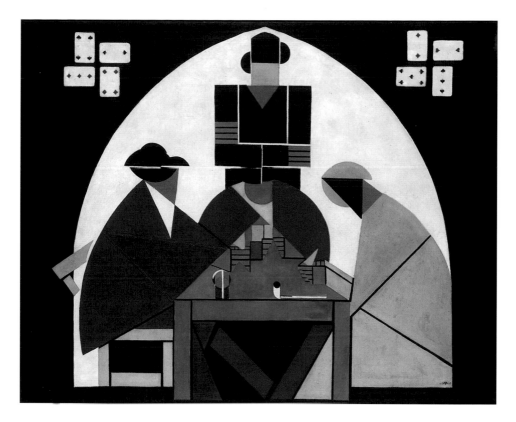

CARD PLAYERS, Theo Van Doesburg

CARD PLAYERS, Theo Van Doesburg

THE NIGHT CAFE

1888

Vincent Van Gogh

Born: 1853, Groot-Zundert, Holland Died: 1890

oil on canvas, 28 1/2" x 34 1/4"

Yale University Art Gallery, bequest of Stephen Carlton Clark, B.A. 1903

Among the best known and most popular painters in all of history, Vincent Van Gogh is classified most often as a Post-Impressionist. Van Gogh lived only 37 years, during which time he never experienced even the smallest measure of success. His father was a clergyman and his brother, Theo, an art dealer. Vincent studied drawing in Brussels, then continued his art education at the Academy at Antwerp. After joining his brother in Paris, he met several Impressionists and became friendly with Gauguin and Toulouse-Lautrec. He later settled in Arles in the south of France, where he developed his own personal painting style. Van Gogh suffered from mental illness throughout his short life and spent some time in an asylum. Following his release, he returned to Paris where he relapsed and, in a state of deep depression, fatally shot himself.

The pocketless table and three balls, two white and one red, indicate a carom billiards game. Carom billiards is popular in France and other European countries, as well as in Africa, South America, and the Far East. The earliest references to billiards of any sort date back to 15th-century Europe.

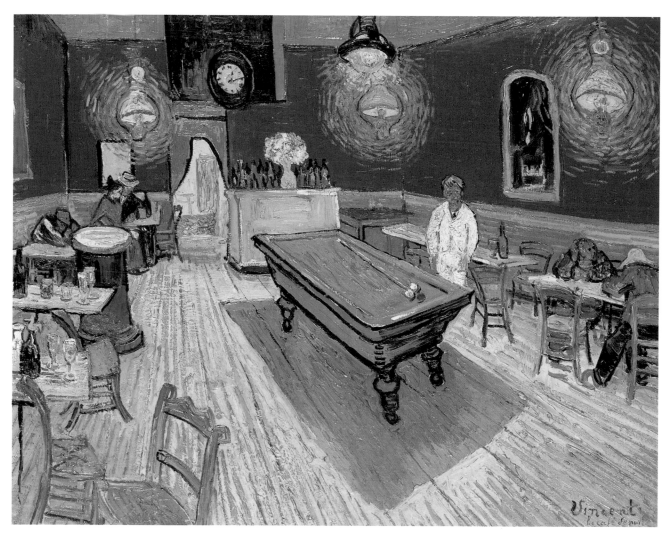

THE NIGHT CAFE, Vincent Van Gogh

THE FARO LAYOUT AT THE MINT SALOON

1934

Olaf Carl Seltzer

Born: 1877, Copenhagen, Denmark Died: 1957

oil on board, 4 1/4" x 6 1/4"

From the collection of Gilcrease Museum, Tulsa, Oklahoma

As a child and preteen, Olaf Carl Seltzer studied at the Danish Art School and the Polytechnic Institute in Copenhagen. At the age of 14, he immigrated with his mother to Great Falls, Montana, where he worked on ranches as a cowhand and was employed by the Great Northern Railroad. During his leisure time, he made pen-and-ink drawings, and with encouragement from his neighbor, Charles M. Russell, Seltzer embarked on a career as an oil painter. Although he spent most of his professional life in the shadow of Russell, the two artists' styles and subjects were similar, and Seltzer benefited from those similarities due to the great demand for Russell's work. Ultimately, Seltzer was recognized as one of the Wild West's great artists in his own right; during his lifetime, he completed approximately 2,500 paintings.

Faro was the most popular "banking game" in America prior to the rise of craps. Faro's roots reach all the way back to the mid 15th-century Italian game of *basset,* which became the French *pharaon.* The game came to the United States by way of New Orleans, where its name evolved into faro, or farobank. Faro was dealt on riverboats and in Western saloons during the 19th century, as well as in Nevada's early 20th-century mining towns of Tonopah and Goldfield. Establishments that offered the game often advertised outside by displaying the image of a tiger, which led to the euphemism "bucking the tiger" for playing against the bank. Despite its incredible popularity, faro eventually disappeared from the casino scene. One reason is that the house advantage is very slight (frontier operators often ran crooked games to overcome this). But additionally, faro is complex, requiring an elaborate layout and excessive space, as can be seen in Seltzer's depiction.

THE FARO LAYOUT AT THE MINT SALOON, Olaf Carl Seltzer

THE CARD PLAYERS

1978

Hale A. Woodruff

Born: 1900, Cairo, Illinois, USA Died: 1980

oil on canvas, 36" x 42"

Courtesy of Bank of America Corporation

Hale A. Woodruff was born to poverty, and his father died shortly after his birth. The family moved to Nashville, where Woodruff's mother worked as a domestic; she had some drawing skills, which she imparted to her young son. Often left home alone, Woodruff became quite accomplished at an early age at copying and sketching cartoons from the local newspapers. He managed to work his way to Paris where he studied, and was profoundly influenced by, the art of Cézanne. Woodruff also studied mural art with Diego Rivera in Mexico, which led to his successful production of the "Amistad" murals, depicting the slaves who mutinied on a slave ship and were later tried and freed in the United States.

"The Card Players" has the distinct look of a gin game, despite the fact that not all the elements of the game are evident. Gin rummy burst onto the scene in the 20th century to become the dominant two-man card game in America. An outgrowth of traditional rummy games, gin became popular among the Hollywood set in the '30s and '40s, which had much to do with its meteoric rise. Gin is a ferocious gambling game, popular for betting because of its short-term reliance on both luck and skill. The game is predominantly skill-based, however, and the best player enjoys a significant advantage over time. Gin is played, and gambled on, in clubs, cardrooms, bars, and homes across America. It has several cousins, such as the gambling game of tonk.

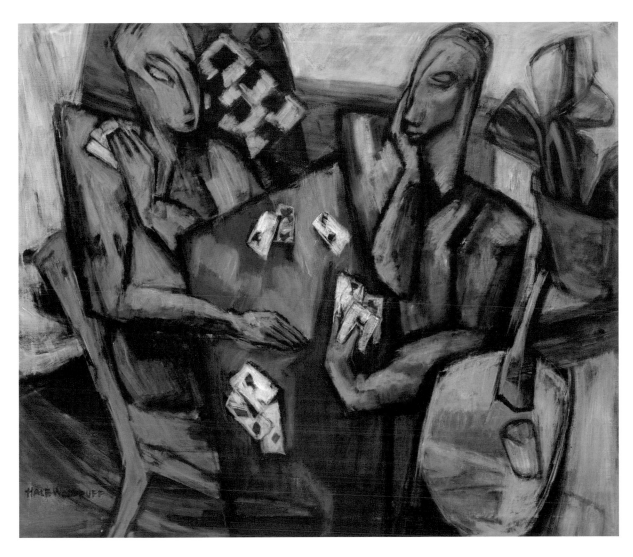

THE CARD PLAYERS, Hale A. Woodruff

COMPOSING MUSIC BY THROW OF THE DICE
c. 1970
Hans Haem
Whereabouts of work unknown

Biographical information about Hans Haem could not be obtained.

Gambling isn't limited to game playing. In this image, a musician trusts a portion of his composition to chance by letting a dice roll determine his next decision. Using dice as a randomizer for music seems the musical equivalent of Jean Arp's free-falling collage (see page 28).

SMALL BUSINESSMAN
c. 1945
Fletcher Martin
Born: 1904, Palisade, Colorado, USA Died: 1979
oil on canvas, 30" x 20"
Courtesy of Mrs. Jean Martin Wexler, East Hampton, New York
Whereabouts of work unknown

For biographical information about Fletcher Martin, see page 28.

In this image, Martin depicts a carnival operator ("carnie") circa the mid '40s. In those days, the operators traveled from city to city, spending two or three days in one locale, then moving on to another. The link between carnivals and gambling is very strong. Operators made money in either of two ways: They cheated by offering games that were impossible to beat (called "gaffed" or "flat" games), or they ran "PC" (percentage) games. The PC games were conducted honestly but were mathematically engineered to ensure a big edge for the operator—much the same as in a casino.

COMPOSING MUSIC BY THROW OF THE DICE, Hans Haem

SMALL BUSINESSMAN, Fletcher Martin

PLAYING CARDS
1978
Clementine Hunter
Born: c. 1886, Hidden Hills Plantation, Louisiana, USA Died: Date unknown
oil on canvas board
From the collection of Thomas N. Whitehead

Often referred to as the "Southern Grandma Moses," Clementine Hunter was one of the most prolific and successful artists of her time, despite the fact that she did not begin to paint until she was in her 50s. Her grandparents were plantation slaves in Louisiana, and Hunter could neither read nor write, but she could tell colorful and joyous stories with her paintbrush. She painted strictly from memory and had a natural sensibility for brilliant hues. Her 5,000-7,000 paintings chronicle a way of life on Southern plantations. Many critics have described Hunter as a naive and primitive artist, while others cherish her as a folk icon. Regardless of how her work is judged, Clementine Hunter remains one of America's most admired artists. She enjoyed working on her canvases well past the age of 100.

Rummy games of all types have been extremely popular in America since the turn of the 20th century. Indeed, most two-player depictions of card players during this era seem to represent a contest of rummy or gin. Early rummy games that sustained their popularity were the Mexican-derived *conquian* and its American cousin coon can. The rummy game that became most associated with women, especially elderly women, however, is canasta. Today, women also gather in commercial cardrooms around the United States to gamble at the rummy derivative called panguingue, or pan.

POKER PLAYERS
c. 1930
John Beauchamp
Born: 1909, Provincetown, Massachusetts, USA
oil on canvas, 52" x 69"
Courtesy of Rita A. Quam, Las Vegas, Nevada

During the Great Depression, a period when many artists suffered through difficult times, John Beauchamp prospered. In addition to using the time afforded by the lack of regular work to paint—the genre was referred to as "Depression Art"—Beauchamp found employment painting Work Progress Administration murals, which may be the reason that his canvases are so large. Beauchamp apparently spent considerable time in Nevada, where several of his original paintings have been sighted, especially in Las Vegas.

Scenes such as this one, of cowboys playing a game of "stud" for chips, will always be associated with the American pioneer spirit. Poker has become so much a part of the American mosaic that many of the game's terms have found their way into the everyday lexicon, including "an ace in the hole," "standing pat," "calling a bluff," "tapping out," and "penny ante."

PLAYING CARDS, Clementine Hunter

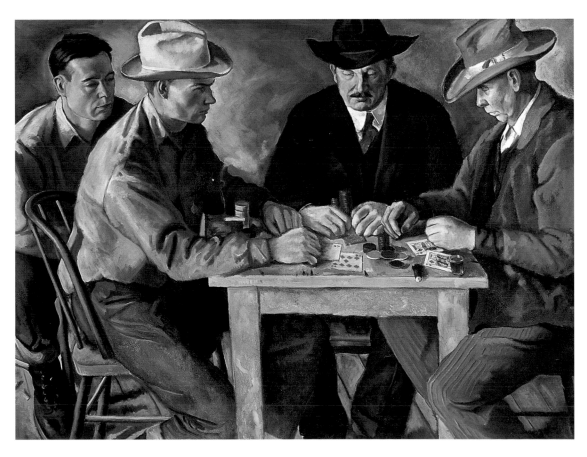

POKER PLAYERS, John Beauchamp

THE POOL GAME

1970

Jacob Lawrence

Born: 1917, Atlantic City, New Jersey, USA

gouache on paper, 22" x 30"

Emily L. Ainsley Fund. Courtesy of the Artist and the Museum of Fine Arts, Boston

For biographical information about Jacob Lawrence, see page 48.

The venue in this painting has the look of a pool room or pool hall. Pool halls can be found in most major cities, and gambling on the various pool games, though technically illegal, is prevalent. Perhaps the greatest (true) rags-to-riches story in gambling history—the $17 million run of Archie Karas in 1992—began with a game in a Las Vegas pool hall. The pool game depicted here appears to have multiple participants. Pool games that are particularly well-suited for gambling with more than two players are three-ball, nine-ball, and rotation.

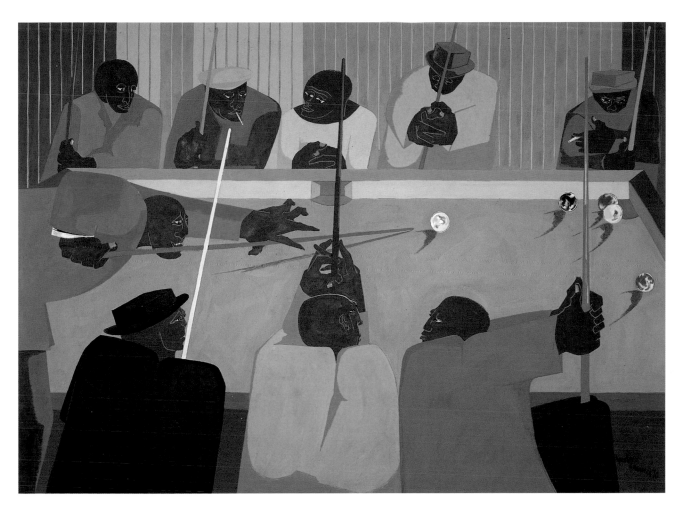

THE POOL GAME, Jacob Lawrence

GAME OF CARDS

1942

Abraham Rattner

Born: 1895, Poughkeepsie, New York, USA Died: Date unknown

oil on canvas, 39 1/2" x 32"

Kennedy Galleries, New York

The art of Abraham Rattner, an American-born Expressionist, was influenced mostly by Cubism and Futurism, and resembled the work of Rouault and Van Gogh more than that of the classic German Expressionists. Rattner began his art education at George Washington University and the Corcoran School of Art. Later he studied at Ecole des Beaux-Arts in Paris and lived and painted for a while in Giverny, France. His work was noticed by the art world when he illustrated the article "Fire," by John Dos Passos, in *Verve* magazine. Later in his career, Rattner spent some time as Distinguished Visiting Professor in the art department at Michigan State University.

Most discussions of women and card games invoke rummy and bridge, usually within the context of a serene setting such as the one depicted here. There is a prevalent belief among men that the fairer sex, for some reason, is precluded from proficiency in games of chance. This perception gives skilled female players an enormous edge in gambling. Women who are adept at exploiting the myth subscribed to by their male opponents have logged many great gambling successes, from profiting as proprietors of gambling halls in the Old West, to baiting and beating testosterone toughs over a poker table, to counting cards at blackjack under the patronizing eye of a casino pit boss.

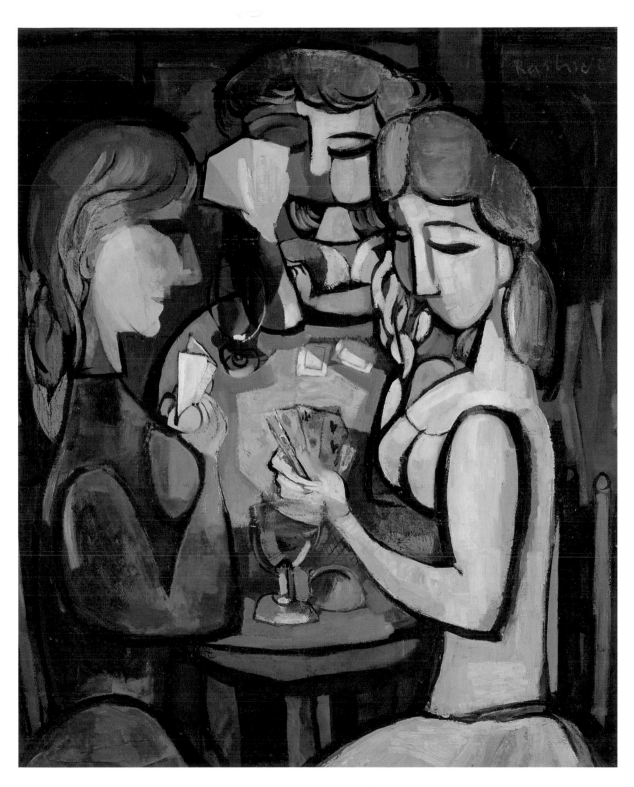

GAME OF CARDS, Abraham Rattner

THE FOUR TIMES OF THE DAY: AFTERNOON (THE GAME OF BACKGAMMON)

1739

Nicholas Lancret

Born: 1690, Paris, France Died: 1743

oil on copper, 28.6 cm x 36.8 cm

© National Gallery, London

Getting an early start on his art studies in Paris, Nicholas Lancret was 15 when he enrolled at the Royal Academy. Later, as a well-known painter, engraver, illustrator, and decorator, he was accepted into Parisian high society as an artistic chronicler of the rich and famous; his work was highly sought after by wealthy art collectors.

To the world at large, backgammon appears to be the genteel aristocratic game that was a common pastime for Lancret's subjects. To the gambling world, however, it's one of the most perfect wagering games ever devised. This is due to a unique piece of equipment known as the "doubling cube." Introduced in America in the 1920s and now incorporated universally, the cube—which is a larger die marked with the numbers 2, 4, 8, 16, 32, and 64—is used specifically as a utility for gambling, allowing stakes to be doubled and redoubled without limit. Skillful use of the doubling cube can result in a significant advantage in the game. In fact, many backgammon strategy decisions can be accurately quantified by the laws of probability, which is why a select group of successful "backgammon hustlers" flourishes around the world.

THE FOUR TIMES OF THE DAY: AFTERNOON (THE GAME OF BACKGAMMON), Nicholas Lancret

INDIANS OF CALIFORNIA GAMBLING

c. 1841

William H. Meyers

Born: 1815 Died: Date unknown

The Bancroft Library, University of California at Berkeley

A self-taught artist, William H. Meyers used a watercolor sketchbook to chronicle his travels as a gunner on a U.S. warship. "Indians of California Gambling" was created during an expedition around Cape Horn to California and Hawaii between 1841 and 1844.

It is believed that this scene was intended to portray Castanoan tribesmen shooting dice for a small animal. North American Indians wagered not only small animals, but also important livestock, such as cows and horses. These were the original high rollers, unafraid to bet items of great material or sentimental value. This wagering spirit has carried through to the present day, as several Native American casinos now rank among the largest in the world, including the largest of all, the Mashantucket Pequot's Foxwoods in Ledyard, Connecticut.

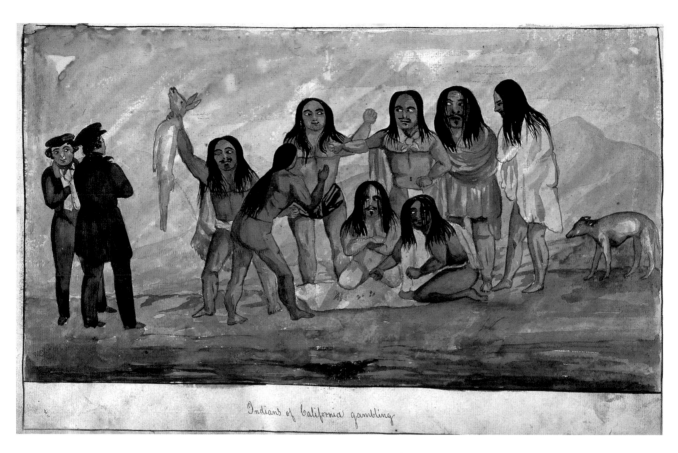

INDIANS OF CALIFORNIA GAMBLING, William H. Meyers

THE BULL RING

1997

Arlene La Dell Hayes

Born: 1952, Lubbock, Texas, USA

oil on canvas, 42" x 36"

Courtesy of the Artist and Alexandra Stevens Gallery of Fine Art, Taos, New Mexico

Raised in a family that was steeped in traditional art, Arlene La Dell Hayes studied at Texas Tech University and the Bellas Artes in San Miguel de Allende, Mexico. Her oil, pastel, and acrylic paintings are designed to portray everyday life in New Mexico. Although a painter of considerable repute, Hayes also has developed a stellar reputation as a sculptor in bronze, stone, clay, and plaster.

The Bull Ring is a long-established restaurant and bar in Santa Fe. Notice the card game in progress at one of the tables in this eponymous image. Many bars around the United States have taken advantage of relaxed restrictions on patrons participating in low-stakes games of chance, usually poker. As poker is a game that cannot be banked by the house, the sponsoring establishment generally makes its profit by charging "time," which is an hourly fee to play, or by taking a "rake," which means keeping a small percentage of each pot. In the poker rooms of major casinos, the former is used in high-limit games and the latter in low-limit games.

THE BULL RING, Arlene La Dell Hayes

ACE OF CLUBS

1914

Pablo Picasso

Born: 1881, Malaga, Spain Died: 1973

collage (oil, pencil, charcoal, paper on board), 45.5 cm x 38.5 cm

Yale University Art Gallery, John Hay Whitney (B.A. 1926, Honorary M.A. 1956) Collection © 1999
Estate of Pablo Picasso/Artists Rights Society (ARS), New York

For biographical information about Pablo Picasso, see page 10.

ACE OF CLUBS

c. 1945

Salvador Dali

Born: 1904, Figueras, Catalonia, Spain Died: 1989

Courtesy of Andy Tompkins, Las Vegas, Nevada/On public display at
the Lady Luck Hotel and Casino, Las Vegas © 1999 Artists Rights Society (ARS), New York

The controversial Surrealist Salvador Dali was one of the most popular artists of the 20th century. While studying at the Madrid School of Fine Arts, he was intrigued by Cubism and simultaneously attracted to Impressionism and Futurism. But he became a full-fledged member of the Surrealist movement after meeting Picasso. Following his reading of Sigmund Freud, Dali developed a passion for the study of the unconscious and the interpretation of dreams in his paintings. His artistic style exerted a strong influence on fashion and advertising during the eight years (1940–1948) he lived in the United States. Though his work and ideas continue to provoke disputatious discourse, Dali remains one of the most illustrious artists of our time.

Though both Picasso and Dali are Spanish, their interpretations of playing cards feature the French-style clubs (the Spanish equivalent is swords; the Spanish deck includes clubs, but they are literal clubs that correspond to the French spades). Dali's card is splashier, incorporating some of the elements of a tarot card. The Cubists' preoccupation specifically with the ace of clubs is noteworthy: Compositions by Georges Braque and Juan Gris are also titled "Ace of Clubs," and the card is present in Picasso's "Card Players" (see page 11) and Gris' "Playing Cards and a Glass of Beer" (see page 197).

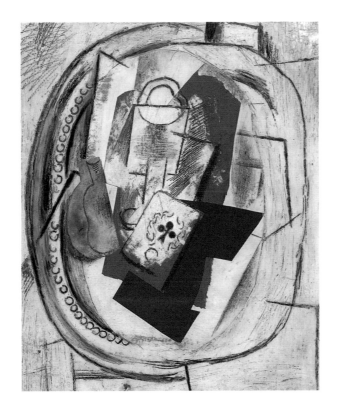

ACE OF CLUBS, Pablo Picasso

ACE OF CLUBS, Salvador Dali

LOTO

1865

Charles Chaplin

Born: 1825, Les Andelys, France Died: 1891

oil on canvas, 45 5/8" x 38 1/4"

Musée des Beaux-Arts, Rouen, France © Giraudon/Art Resource, New York, New York

Charles Chaplin was born of an English father and a French mother, and appears to have been influenced by French art and artists. Known primarily for his portraits of women and children, Chaplin was also highly successful with his portrayals of landscapes, as well as genre and mythological scenes. His early genre scenes, including "Loto," were modeled on the works of Fragonard and Chardin.

From Biblical references to Moses divvying up the promised land to today's state-sponsored fiscal cure-alls, the lottery has endured as history's most prolific gambling activity. Embraced by gamblers (legal and illegal), governments, and representatives of all social classes, lotteries have taken many forms—from the humble game of Italian origin played here by children to keno, bingo, raffles, parlay cards, illegal "numbers" rackets, and multistate affairs touting multimillion-dollar jackpots. In general, lotteries share two common traits: They are highly profitable enterprises for the sponsors and highly disadvantageous gambles for the participants.

LOTO, Charles Chaplin

D.I. BACCARAT

1997

LeRoy Neiman

Born: 1927, St. Paul, Minnesota, USA

oil on board, 48" x 72"

Collection of Desert Inn Hotel and Casino, Las Vegas, Nevada/On public display

For biographical information about LeRoy Neiman, see page 24.

Neiman's "D.I. Baccarat" depicts a semi-private baccarat salon at Las Vegas' Desert Inn. To maintain an aura of exclusivity, casinos go to great lengths to separate baccarat from the other games: The baccarat pit is opulent and cordoned off from the rest of the casino floor; dealers work in tuxedos and observe all manner of protocol; food and drinks are provided. This level of service has come to be expected by baccarat devotees, the biggest gamblers in the casino. The minimum bet in the baccarat rooms of Las Vegas and Atlantic City runs around $100 per hand, and it's not unusual for the highest rollers to wager tens of thousands of dollars per round. The biggest of the biggest are known as "whales." They have multimillion-dollar lines of credit and have been known to issue tips the size of a house mortgage. The result of a whale's weekend of gambling can impact the quarterly balance sheets of even the biggest casino corporations.

D.I. BACCARAT, LeRoy Neiman

1631

Dirk Hals

Born: 1591, Haarlem, Holland Died: 1656

oil on panel, 32.6 cm x 27.7 cm

Sterling and Francine Clark Art Institute, Williamstown, Massachusetts

Dirk Hals, the brother of well-respected painter Frans Hals, was born in Haarlem, Holland, and worked for a time in Lieden, the home of several famous Dutch artists. Like many of his fellow painters, Hals shared a penchant for portraying human facial features as joyful but exaggerated, almost to the point of abnormality. "Children Playing Cards" exemplifies another proclivity of the period's painters: representing small-scale genre scenes, especially those depicting "merry-company" gatherings.

The connection between children's games and gambling is striking. Gambling creeps into children's game playing early on, when they start shooting marbles, pitching pennies, or flipping baseball cards. What's more, many of the card games children have played through the ages (pig and go fish) are scaled-down versions of card games that adults use for gambling (rummy and cassino). The common bond is simplicity. Games must be simple, not only to be understood by children, but also to be enjoyed by gamblers. The best example is war, also known as battle, a universal kids' game that is thought to have derived from an ancient gambling game and today has come full circle as a bona fide casino table game called Casino War.

CHILDREN PLAYING CARDS, Dirk Hals

THE BRIDGE GAME

1948

Norman Rockwell

Born: 1894, New York City, New York, USA Died: 1978

Cover, *Saturday Evening Post* (May 15, 1948) © The Curtis Publishing Company,
printed by permission of the Norman Rockwell Family Trust, © 1948 the Norman Rockwell Family Trust

Perhaps the most famous and beloved painter and illustrator in American art history, Norman Rockwell was born in New York City and trained there at the Art Students' League. His trademark was the portrayal of ordinary people seen in everyday life. His images were always warm, humorous, and comforting, and they represented an honest, innocent, and patriotic America. Rockwell was renowned for paintings and illustrations that appeared on the covers of the *Saturday Evening Post, Look,* and the *Ladies Home Journal.* He created more than 300 covers for the *Saturday Evening Post.*

Bridge took American and European high society by storm around the turn of the 20th century. The game evolved relatively quickly into the formats of auction bridge, then contract bridge, the latter considered among the most skill-oriented card games ever devised. As such, bridge adapts well to playing for stakes, especially in its tournament format, known as duplicate bridge. Bridge games are particularly vulnerable to cheating, most commonly by partners conveying information by signaling.

THE BRIDGE GAME, Norman Rockwell

POKER GAME

c. 1985

Israel Rubenstein

Born: 1944, Petah Tikvah, Israel

printed in 41 colors on Arches France paper, 38 1/2" x 31 3/8"

Courtesy of Larry Grossman, Las Vegas, Nevada

A native of Israel, Rubenstein studied at the Tel Aviv School of Art. He once maintained a studio in the SoHo district of New York City, where he produced "Poker Game."

Though biographical information on Rubenstein is sparse, the artist's own explanation of his work portraying a five-card draw poker game is known. Each of the men faces a situation that's familiar to anyone who has played poker. The man pictured on the far left is in Seat No. 1, and the seats progress clockwise around the table. Seat No. 1: His stake is down to next to nothing (in poker lingo, "close to the felt")—he's watching every chip. Seat No. 2: He needs one card to make his hand ("drawing slim")—it's the ace of clubs, which can be seen in his head. Seat No. 3: He's completely disgusted after losing everything ("busted"). Seat No. 4: He holds a royal flush—a no-brainer.

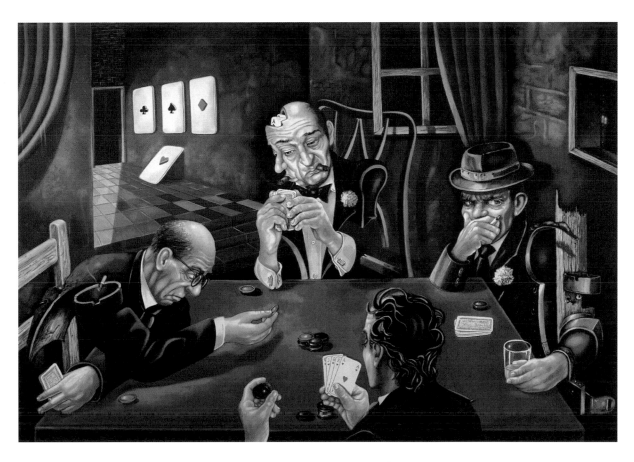

POKER GAME, Israel Rubenstein

FRIENDLY GAME
1958
Fletcher Martin
Born: 1904, Palisade, Colorado, USA Died: 1979
oil on canvas, 36" x 28"
Courtesy of Mrs. Jean Martin Wexler, East Hampton, New York
Whereabouts of work unknown

For biographical information about Fletcher Martin, see page 28.

The title of Martin's classic poker scene belies the true nature of winning play. Poker, taken to its highest level, is anything but friendly. It's a game of subterfuge, misrepresentation, and ruthlessness, underscored by the terms that describe its most powerful tactics: "sandbag," "slow-play," "bluff," and "trap." Many consider the purest form of poker to be no-limit, a test in which nerve and psychological fitness often transcend even mathematical superiority.

THE CARD GAME
1950
Count Balthus
Born: 1908, Paris, France
oil on canvas, 55" x 76 ⁵/₈"
Whereabouts of work unknown

Born Count Balthazar Klossowski De Rola, Balthus came from a family of artists. His father was a highly successful stage designer and painter. His mother introduced him to the poet Rilke, who was responsible for Balthus' first publication of illustrations and was instrumental in acquainting him with the Parisian art world. Throughout his career, Balthus was influenced by Surrealism. He developed into an accomplished stage designer, following in his father's footsteps, and made a grand career as a portrait painter.

Balthus' quirky image provides little evidence of the game played. Whatever it is, the boy with a card hidden behind his back appears to seek an unfair advantage. In modern-day gambling, new scientific methods for gaining an edge—card counting, computer analysis, neural networks—are lumped in with age-old "crossroading" (cheating) techniques and categorized under a single term: "advantage play."

FRIENDLY GAME, Fletcher Martin

THE CARD GAME, Count Balthus

MONKEYS PLAYING CARDS

c. 1650

David Teniers the Younger

Born: 1610, Antwerp, Belgium Died: 1690

Pushkin Museum of Fine Arts, Moscow, Russia © Scala/Art Resource, New York, New York

Of all the Teniers family of Flemish painters, David Teniers the Younger is best known. Born in Antwerp, he was trained by his father, David Teniers the Elder. Chiefly influenced by Adrian Brouwer and his "low-life" genre paintings, Teniers the Younger became most recognized for his depictions of peasant life, landscapes, and religious scenes. Much of his work portrayed peasants entertaining themselves in taverns—playing cards, dice, and skittles.

The artist was way ahead of the curve with regard to the portrayal of animals engaged in gambling; "Monkeys Playing Cards" predates the other four such images in this volume by nearly 250 years. It's likely that Teniers was lampooning the ubiquitous gambling in Europe during the period—drawing an insulting intelligence comparison between monkeys and gamblers.

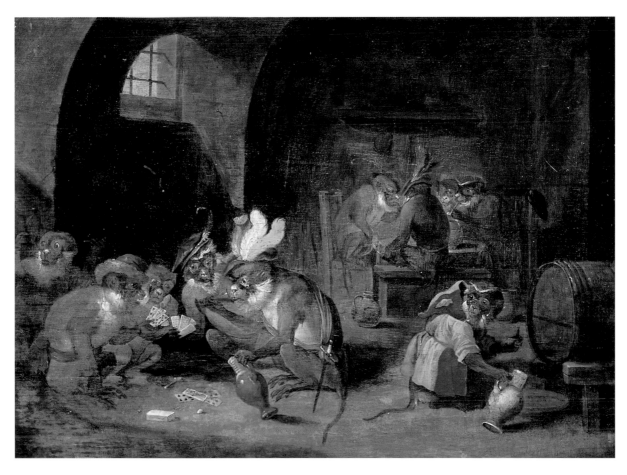

MONKEYS PLAYING CARDS, David Teniers the Younger

PLAYING CARDS IN A TENT

1905

Frank Schoonover

Born: 1877, Oxford, New Jersey, USA Died: 1972

oil on canvas, 20" x 30"

Glenbow-Alberta Institute, Calgary, Alberta, Canada

For biographical information about Frank Schoonover, see page 58.

Time spent in Canada may have led Schoonover to portray a Canadian gambling game called forty-five, in which players vie for a pot that's carried forward to the next round if no one wins the requisite number of tricks. Forty-five is a descendant of the Irish game, spoil five.

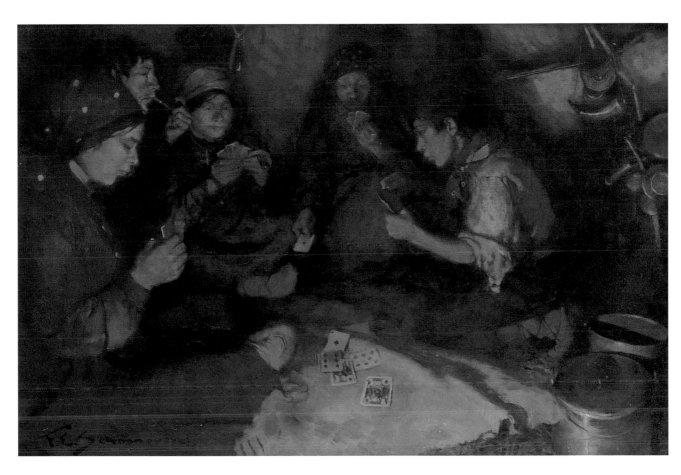

PLAYING CARDS IN A TENT, Frank Schoonover

VIRTUE WINS

1998

Henry M. Conversano (designer)/Mario Chiodo (artist)

Born: 1931, New York, New York Born: 1961, Oakland, California

sculpture: steel armature, rigid foam, magic sculpt, epoxy resin, acrylic paint, height 6' 2", base 3' 6" x 3

Courtesy of Harrah's Hotel and Casino, Las Vegas, Nevada/On public display

"Virtue Wins" was designed by Henry M. Conversano and created by Mario Chiodo. A world-renowned designer of casinos, hotels, and restaurants, Conversano made his mark in the gambling industry by designing the Mirage in Las Vegas, the Reserve in neighboring Henderson, and the Lost City at Sun City Resort in Sun City, South Africa. Chiodo, a native of Oakland, California, is considered the pre-eminent sculptor of the Halloween and fantasy-sculpture industry. Conversano and Chiodo forged a partnership to create this striking sculpture, which they originally titled "Greenbacks."

This unusual merging of historical and contemporary within the context of a poker game has the two men of the Old West cheating the modern showgirl by exchanging a card beneath the table. The chips on the table sport the red, green, black, purple, and yellow hues of the Harrah's $5, $25, $100, $500, and $1,000 chips, respectively.

VIRTUE WINS, Henry M. Conversano/Mario Chiodo

For biographical information about Charles M. Russell, see page 26.

A reading of Russell's phonetically written note makes his intent clear. He writes that "in the game of love, men are crooked," and illustrates the sentiment with a bridegroom receiving a "hand-off" (aces) from the devil, while engaged in a poker game with Cupid.

James Gillray was one of the most prolific engravers in history, producing more than 1,500 prints in his lifetime. Gillray is given credit for inventing the popular genre of English political caricature. In 1780 he produced two highly respected prints illustrating Henry Fielding's novel, *Tom Jones*. After becoming disgusted with domestic politics, Gillray concentrated on social satire. He also was known for his strong anti-Napoleonic cartoons. Later in his life, Gillray was plagued with a variety of nervous illnesses and went insane.

The aristocratic partnership game of whist was popular in England for nearly two centuries, from the mid 1700s up to the early 1900s. Whist was the predecessor of bridge and countless other derivatives, including some with reputations in gambling circles, such as knockout whist, oh hell, and a game reputed to be played during the Vietnam War called back alley.

LETTER TO FRIEND CAL, Charles M. Russell

TWO-PENNY WHIST, James Gilray

GAME OF CHANCE

c. 1853

John Mix Stanley

Born: 1814, Canandaigua, New York, USA Died: 1872

oil on canvas, 27 $^1/_2$" x 38 $^5/_8$"

From the collection of the Gilcrease Museum, Tulsa, Oklahoma

For biographical information about John Mix Stanley, see page 6.

The gambling of Native American tribal peoples was deeply rooted in their sacred mythology. It was thought that to be the recipient of good luck, an Indian player had to constantly appease and gratify the gods. It was further believed that gambling itself was a form of appeasement. But to gamble and win was to be elevated to a position to seek further divine blessings. The gods could be counted on to help in fighting and expelling evil spirits and demons. The winners could expect to be endowed with human and crop fertility. And most important, they would be the beneficiaries of good health. All this from a game of chance.

GAME OF CHANCE, John Mix Stanley

PATIENCE

1942

Georges Braque

Born: 1882, Argenteuil, France Died: 1963

© 1999 Artist Rights Society (ARS), New York/ADAGF, Paris

Whereabouts of work unknown

A close friend and associate of Picasso, Georges Braque began his career by studying painting at night school in Le Havre, France. As was true for many of the young European artists of the period, Braque was drawn to the painting style of Paul Cézanne. Braque and Picasso began to experiment with Cubism and became active leaders in the popular movement. The two artists worked so closely together that for a time their paintings were difficult to tell apart. Braque was also one of the pioneers in the development of the "collage" technique. Much of his work utilized the combination of different shapes made from pieces of wallpaper, newspapers, fabrics, and other materials, which he glued onto canvas. During the latter part of his career, Braque painted figures, still lifes, and beautiful landscapes, distancing his work from his earlier severe geometrical art.

Patience is the name of the vast family of card games known in the United States as solitaire. While, by definition, solitaire is a one-man game, various competitive two-player versions have been developed, which can turn into intense and animated speed competitions when a wager hangs in the balance. Solitaire's main claim to gambling fame, however, was its stint as a casino game. Played predominantly in illegal casinos, gamblers put up $50 for the deck and played a version of solitaire called Canfield, winning back $5 for each card successfully making it to the suited stacks known as the "foundation." Las Vegas casinos experimented with Canfield, but the game did not catch on.

THE CARD PLAYERS

1928

Marcel Gromaire

Born: 1892, Noyelles-Sur-Sambre, France Died: 1971

oil on canvas, 81 cm x 100 cm

Musée National d'Art Moderne, Troyes, France

Marcel Gromaire initially set out to pursue a legal career, but he was sidetracked by art and soon became a painter despite little formal training. He imitated the style of Matisse, then adopted the technique of the Flemish painters; he also admired the German Expressionists. Gromaire was an ardent foe of fascism, in both his art and his writings. He most enjoyed painting cityscapes, landscapes, nudes, and scenes of festive peasants and urban working-class people.

Gromaire's card players are engaged in a three-man game, which often means playing "cut-throat," named for the tendency of two players to join forces against the third player. Many traditional card games, such as pinochle and hearts, have been modified over time to accommodate cut-throat play. In some cases, the modified version becomes the preferred form.

PATIENCE, Georges Braque

THE CARD PLAYERS, Marcel Gromaire

SURPRISED

1875

Carl Kronberger

Born: 1841, Friestadt, Upper Austria Died: 1921

oil on wood panel, 14 5/16" x 11 1/2"

Milwaukee Art Museum, gift of Rene Von Schleinitz Collection

Although believed to be primarily self-taught, Carl Kronberger had formal training as an architectural decorator in Linz, Austria, and studied painting under Anschutz and Dyk in Munich. Some critics berated his paintings as superficial, calling them "staged little slices of life." The criticism, however, did not dissuade collectors from avidly purchasing Kronberger's work during his lifetime and long after; his meticulously crafted, brightly lighted, and humorous paintings continue to be in great demand to this day.

The game here is being played clandestinely, a consequence of the perception in many circles that cards and gambling always go hand in hand. Cards are sometimes referred to as "the devil's picture book." The pages of this particular picture book are printed in German, as can be discerned from the suits on the cards. The three-man game may be *skat,* or a similar game popular in Austria called *préférence.*

SURPRISED, Carl Kronberger

LES JEUX SONT FAITS

1987

Poucette

Born: 1935, France

Courtesy of Andy Tompkins, Las Vegas, Nevada/On public display at the Lady Luck Hotel and Casino, Las Vegas
© 1999 Artists Rights Society (ARS), New York/ADAGF-Paris

Christened by the New York media in the 1950s with the sobriquet the "Peddling Painter from Paris," Poucette studied in her native France. Her paintings and collages of cheerful Parisian nightlife and street scenes were decorative and lighthearted, but commercially unsuccessful in her own country, which led her to market them in New York. Thanks to a high-spirited personality and likable approach, she was allowed to hawk her art in the lobby of the Plaza Hotel and in Central Park. From there, Poucette entertained art patrons in Texas and Los Angeles in search of her next sale.

This painting—along with its idiomatic title, which means, roughly, "the games have begun"—focuses on the revelry associated with gambling. The image also provides a good look at a French-style roulette wheel. Notice the French *Impair* and *Manque,* which correspond to bets on "odd" and "1-18." More important is the single zero (partially obscured by the croupier's stick). The key to the house edge in roulette is the number of zeros on the wheel. European wheels have a single zero, which results in a 2.7 percent house advantage. Most American wheels employ two zeros, which increases the edge to 5.26 percent. Wheels with three or more zeros sometimes show up in charity-gambling or carnival settings, which are notorious for sucker games and bad odds.

LES JEUX SONT FAITS, Poucette

DENIAL OF ST. PETER

1650

Georges de La Tour

Born: 1593, Lorraine, France Died: 1652

oil on canvas, 120 cm x 160 cm

Musée des Beaux Arts, Nantes, France

For biographical information about Georges de La Tour, see page 4.

The game being gambled on here is impossible to determine, given that three-dice games such as buck dice, help your neighbor, Yankee grab, and crag have been played throughout history in untold variations and under scores of different names. To complicate matters, some games required that a third die be on hand for a second throw only when necessary. Despite the absence of identifying paraphernalia (e.g., a layout), it's possible that this is a banking game called grand hazard. Not to be confused with the two-dice game of hazard, grand hazard was a forerunner of chuck-a-luck and sic bo.

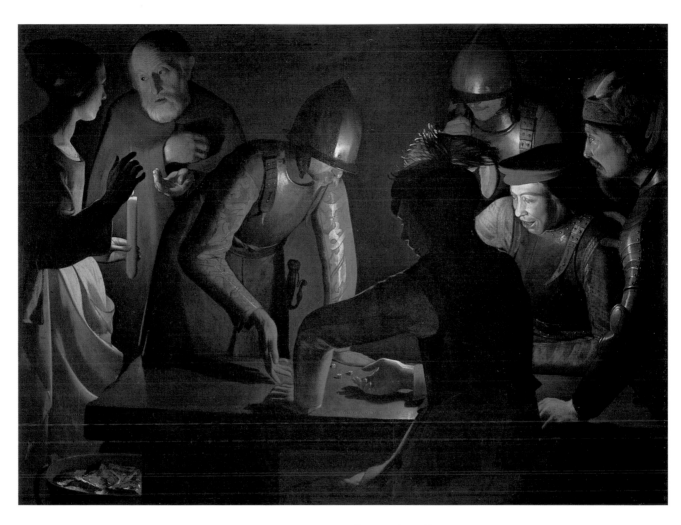

DENIAL OF ST. PETER, Georges de La Tour

CRUCIFIXION

c. 1475

Andrea Mantegna

Born: 1431, Padua, Italy Died: 1506

central panel of the predella of the San Zeno altarpiece

The Louvre, Paris, France

Although Andrea Mantegna's father was a successful carpenter who provided his family with a comfortable living, he had more lofty aspirations for his son: He wanted Andrea to become a great artist, and at an early age the boy was entrusted to a local Paduan painter for upbringing. Mantegna received a classic art education from his adopted father, along with exposure to the works of Paolo Uccello, Filippino Lippi, and Donatello. Mantegna became a master portraitist whose work was characterized by realistic human figures against lavish background scenery. A highly dramatic use of perspective makes his work easily identifiable.

The soldiers pictured in the lower right-hand corner of "Crucifixion" are said to have gambled for the robe of Jesus. However, historical accounts of the incident refer to the soldiers "casting lots." Lots were commonly drawn or cast in the deterministic culture of the Roman Empire simply as a decision-making process, which has led to an ongoing debate over whether gambling was involved at all. Since the robe was sought after as a "jackpot," the soldiers were, indeed, gambling at the cross—involved in one of the most infamous gambling moments in all of recorded history.

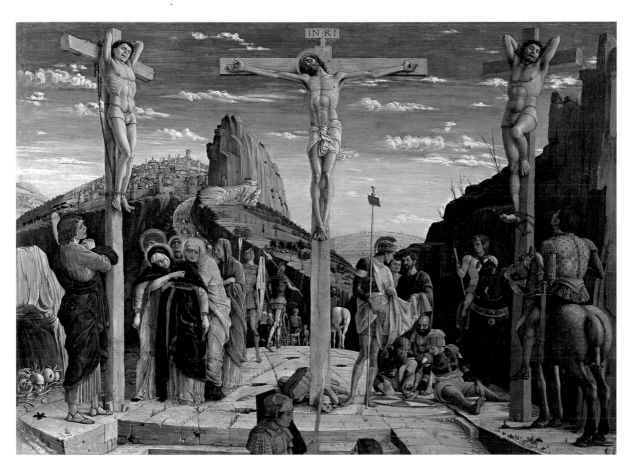

CRUCIFIXION, Andrea Mantegna

PAY DAY

1999

Suz Brna

Born: 1958, Milwaukee, Wisconsin, USA

tinted lithograph, 21" x 15"

Courtesy of the Artist, Las Vegas, Nevada © 1999

For biographical information about Suz Brna, see page 104.

Payday is a big day everywhere, but in Las Vegas it has a special significance for many who work in the gambling industry. Paychecks in hand, casino employees can be found participating from "the player's side" in the very activity that they oversee on a daily basis. This contemporary scene portrays an after-shift dealer taking his ritualistic "shot" alongside other players, both tourists flush with vacation funds and locals with their own paycheck proceeds. The gambling subject in "Pay Day," video poker, is widely considered the most successful new casino gambling game of the latter 20th century.

PAY DAY, Suz Brna

THE GAME OF BEZIQUE

1895

Henri de Toulouse-Lautrec

Born: 1864, Albi, France Died: 1901

lithograph (crayon) in black with hand coloring in watercolor and oil on tan wove paper, 33 cm x 26.8 cm

Kate S. Buckingham Fund, The Art Institute of Chicago

Henri de Toulouse-Lautrec was steered into the world of drawing and painting by "accident." As a consequence of breaking both legs in devastating accidents when he was young, he was left with a permanent disability and ample opportunity to explore his artistic ability while confined to his bed over long periods of time. Coming from an aristocratic family, Toulouse-Lautrec had no difficulty blending into the Parisian art scene as a painter and visited the studios of the most influential artists of the times. He soon decided to live and work in the Parisian bohemian district of Montmartre. He preferred drawing over painting, which allowed him to sketch the fleeting events in the Montmartre environment, and he had uncommon success with posters that depicted the Moulin Rouge scene. Montmartre played many significant roles in Toulouse-Lautrec's life, not the least of which was his plunge into alcoholism that led to paralysis and death at age 37.

The two-handed French game of *bezique* is one of history's great card games, with ancestors and cousins all over the globe. Dating back to about 1700 and the German game of *mariage, bezique* is best known in America as pinochle, which can be played by two or three individual participants or in partnerships with four or six players. Especially well-suited to gambling, *bezique* was reportedly played in the casinos of 19th-century Paris.

THE GAME OF BEZIQUE, Henri de Toulouse-Lautrec

THE DICE PLAYERS

c. 1650

Georges de La Tour

Born: 1593, Lorraine, France Died: 1652

oil on canvas, 97 cm x 130 cm

Preston Hall Museum, Stockton on Tees, England

For biographical information about Georges de La Tour, see page 4.

De La Tour's "The Dice Players," while similar in look to his "Denial of St. Peter" (see page 181), is more representative of play among the gentry. Both hazard and grand hazard were known as high-stakes dice games, especially hazard as it was played in English gambling houses. It's doubtful, though, that stakes were ever as high as they were in 1984, when a Texan made a $1 million bet on a crap table at Binion's Horseshoe in Las Vegas. The man, who had won separate bets of $777,000 and $548,000 on two previous visits, wagered a suitcase full of cash on the pass line. An elderly lady rolled the dice, established a point of nine, then immediately rolled a seven—loser.

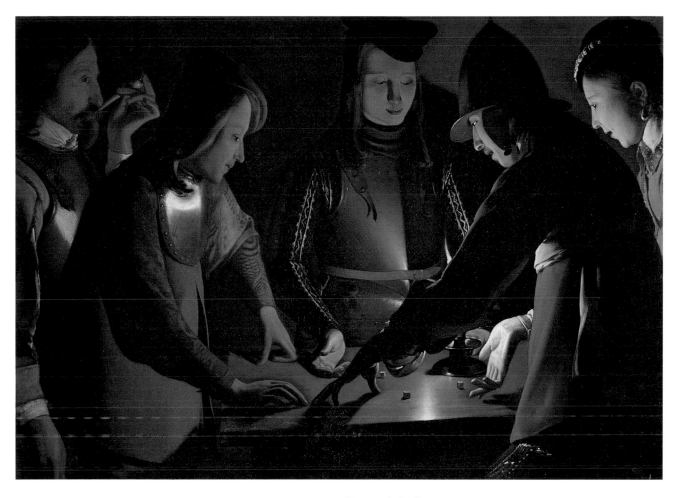

THE DICE PLAYERS, Georges de La Tour

RENAISSANCE CARD GAME

1985

Grace Hartigan

Born: 1922, Newark, New Jersey, USA

oil on canvas, 89" x 110"

Collection of Gene Ewing, Los Angeles, California

For biographical information about Grace Hartigan, see page 108.

Created two years prior to her painting "Casino," Hartigan's "Renaissance Card Game" offers a much milder portrayal of the gambling experience. The artist's selection of the period is probably not a coincidence: The Renaissance of the 14th through the mid 17th centuries was something of a golden age for gambling. Not only were games of chance prevalent, but it was toward the end of this period that probability theory was born. The Italians Cardano and, to a lesser extent, Galileo, provided fundamental contributions to the formulation of this branch of mathematics, followed by the efforts of the French mathematicians Blaise Pascal and Pierre de Fermat. It was Cardano's own addictive gambling habits that led to his most pointed contributions. Later, a specific question about gambling, posed by the Chevalier de Méré, was the stimulus for the defining work of Pascal and Fermat.

RENAISSANCE CARD GAME, Grace Hartigan

THE DICE PLAYERS

c. 1650

Mathieu Le Nain

Born: 1607, Laon, France Died: 1677

oil on canvas, 36 1/2" x 47 1/4"

Rijksmuseum, Amsterdam

The Dutch Le Nain family was celebrated throughout Europe for its paintings. Mathieu Le Nain learned to paint alongside his older brothers Antoine and Louis, and served his apprenticeship in their studio. Following his early training, he left his siblings and worked in Paris, where he became the official painter of the municipality. All three Le Nain brothers were influenced by Caravaggio. "The Dice Players," one of Mathieu Le Nain's earlier paintings, exemplifies not only Caravaggio's style, but also his love of gambling as a subject.

Most multiple-dice games are played with casting devices. Grand hazard used a "chute." Chuck-a-luck was sometimes called "bird cage" for the look of its hourglass-shaped wire shaker. In this image, the players are using the most common casting device: a "dice cup."

THE DICE PLAYERS, Mathieu Le Nain

A highly respected painter, illustrator, and caricaturist, Will Cotton created more than 60 covers for *The New Yorker* magazine. During the '20s and '30s he rubbed elbows with the most admired celebrities of that era and portrayed many scenes of New York society, including "The Thanatopsis Pleasure and Inside Straight Club" and "Lunch at the Astor."

The New Yorker magazine cover of August 25, 1945, depicts a common gambling scene that occurred everywhere servicemen could be found with time on their hands during World War II. Normal "alley craps" seems the likely game, but also popular among the troops was a dice game of Middle Eastern ancestry, particularly favored by players of Greek descent, called *barbooth*.

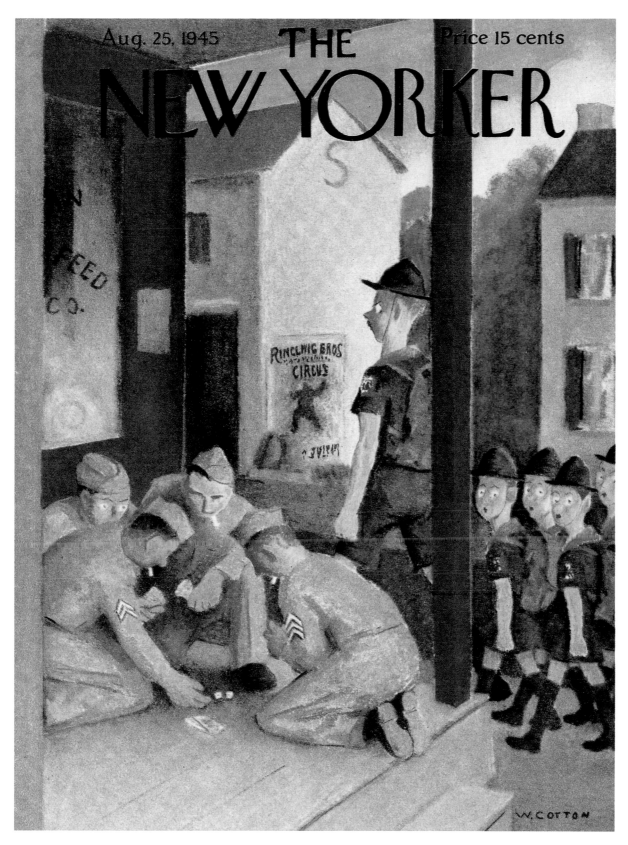

THE NEW YORKER, AUGUST 25, 1945, COVER, Will Cotton

PLAYING CARDS AND A GLASS OF BEER

1913

Juan Gris

Born: 1887, Madrid, Spain Died: 1927

oil and collage on canvas, 52.3 cm x 36.5 cm

Columbus Museum of Art, Ohio, gift of Ferdinand Howald

A popular Cubist painter in his own right, Juan Gris was a colleague of Picasso's. Gris initially studied engineering, but decided he wanted to be an artist. After dabbling with Art Nouveau (Jugenstil), he joined Picasso in Paris and eked out a living by selling humorous drawings to various publications. Gris began to receive critical recognition when he exhibited his "Hommage à Picasso" in the Salon des Indépendants. This work clearly illustrated his own personal concept and style of Cubism.

"Playing Cards and a Glass of Beer" again documents the Cubists' affinity for using playing cards in their compositions. Despite being of Spanish descent, Gris chose to portray cards from a French deck, as is apparent by the presence of the French clubs and hearts, rather than the Spanish equivalents, swords and cups. Gris also incorporated gambling paraphernalia in several of his still lifes, including "The Dice" and "Ace of Clubs."

PLAYING CARDS AND A GLASS OF BEER, Juan Gris

RAFTSMEN PLAYING CARDS

1847

George Caleb Bingham

Born: 1811, Charlottesville, Virginia, USA Died: 1879

oil on canvas, 28" x 38"

The St. Louis Art Museum

Another of the many famous self-taught American artists was George Caleb Bingham. Born on a farm near Charlottesville, Virginia, Bingham served a short apprenticeship as a cabinetmaker before realizing that he was destined to be a painter. He eventually settled in Missouri, where he developed a strong following for his portraits of Midwestern river life and political events. Recognized as an American Genre painter, as well as a politician in his adopted state, Bingham was referred to as a "native talent" by the people of Missouri.

After traders from Europe, the Caribbean, and South America, as well as slaves from Africa, made New Orleans America's gambling hotbed in the early 1800s, a backlash against gamblers (mostly cheats, called "blacklegs") in the 1830s gave rise to the era of the riverboat gambler, which lasted until about 1860. It was by way of the Mississippi River—plied by all manner of craft, from the big steamers to the small raft seen here—that many gambling games spread from New Orleans to the rest of America. One such gambling game of French heritage is boo-ray *(bouré),* which combines elements of poker and trick-taking games, like pinochle.

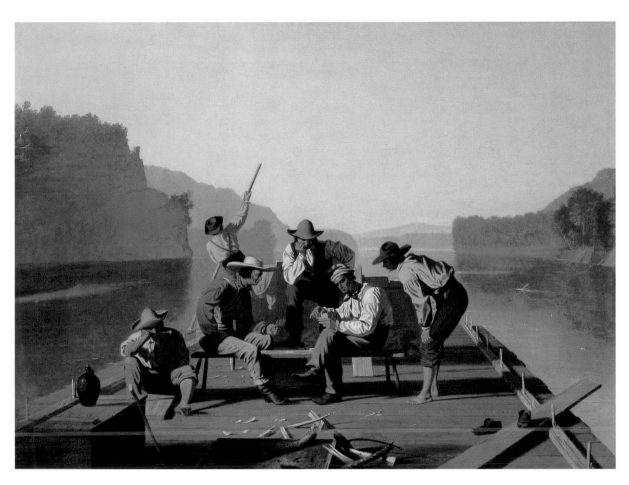

RAFTSMEN PLAYING CARDS, George Caleb Bingham

VEGAS BLACKJACK

1957

LeRoy Neiman

Born: 1927, St. Paul, Minnesota, USA

oil on canvas, 36" x 48"

Private collection

For biographical information about LeRoy Neiman, see page 24.

Neiman's "Vegas Blackjack" portrays the high end of casino gamblers—the business CEOs, real estate magnates, and investment professionals who, whether at work or at play, are happiest when big money is at stake. "They gamble in everything they do," comments the artist. "Playing blackjack is the way they relax."

VEGAS BLACKJACK, LeRoy Neiman

THE POKER GAME

c. 1893

Charles M. Russell

Born: 1864, Oak Hill, Missouri, USA Died: 1926

sculpture: wax on wood and cloth base, height 7 1/8", base 12" x 19 1/8"

Amon Carter Museum, Fort Worth, Texas

For biographical information about Charles M. Russell, and to examine this sculpture's companion piece, "Not a Chinaman's Chance," see pages 26 and 27.

"The Poker Game" appears to be five-card stud, with the Chinese man leaning forward to check his "hole card." Though social prejudice on the frontier is well-documented, gambling among classes and races was common throughout the 1800s—especially in the gambling houses of San Francisco and in the saloons of mining and railroad towns.

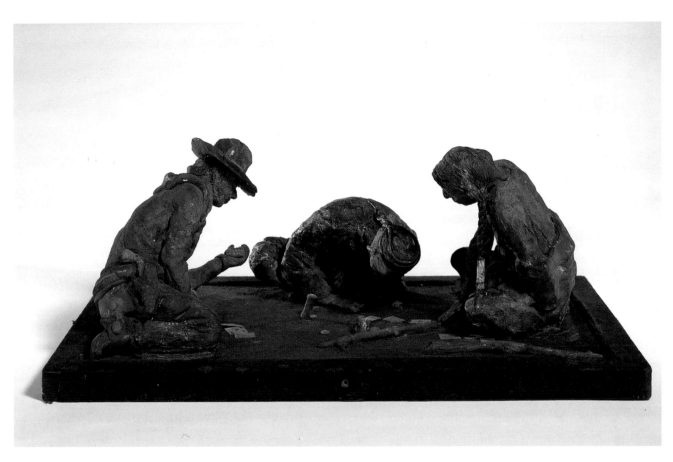

THE POKER GAME, Charles M. Russell

THE SIDING

1936

Philip Evergood

Born: 1901 Died: 1973

oil on canvas, 36" x 27"

Courtesy of ACA Galleries, New York, New York

The German Expressionistic style was embraced during the late 1940s and early 1950s by American artist Philip Evergood, who often used his art to comment on the political and social confusion engendered by the Cold War. Early in his career, Evergood was active in producing "Depression Art," much like John Beauchamp (see page 139).

One of Evergood's most illustrious paintings is "The Siding," in which he portrays the railroad "gandy dancers"—named for the rhythmic movements involved in laying and maintaining track—whiling away their time with a game of poker. These games tended to be played for low stakes: cigarettes, match sticks, toothpicks, and so forth. The featured hand, four aces, will "hold up" unless another player has a straight flush or royal flush.

THE SIDING, Philip Evergood

THE CARD PLAYERS AND GIRL

1892

Paul Cézanne

Born: 1839, Aix-en-Provence, France Died: 1906

oil on canvas, 52 3/4" x 71 1/2"

For biographical information about Paul Cézanne, see page 8.

Card games survive through the ages by being passed down from generation to generation. Here a young girl learns rules and strategy by watching her elders play. The game is indeterminate. There is a specific three-player version of the French *piquet* known as *piquet normand;* however, this could be any one of many three-handed games that were played in France around the turn of the century.

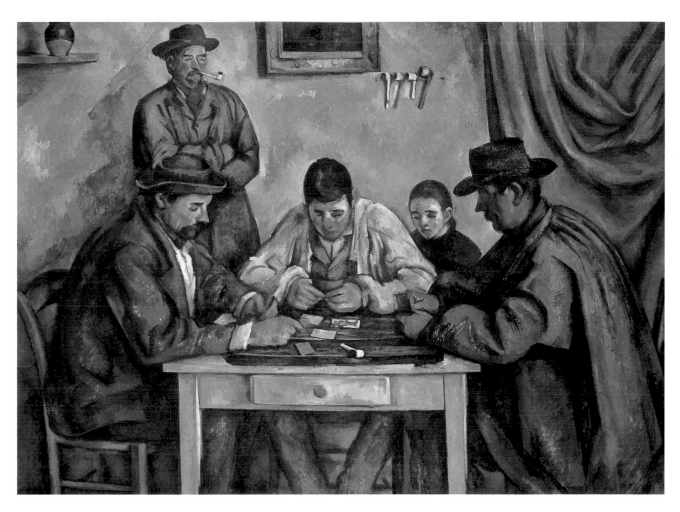

THE CARD PLAYERS AND GIRL, Paul Cézanne

NUMBER TWENTY OR WE'RE BACK TO THE PASTURE
1995
Dwight Davidson
Born: 1949, Rexburg, Idaho, USA
sculpture: ceramic, height 13", base 32" x 17 1/2"

LUCKY DRAGONFLY
1995
sculpture: ceramic and steel, height 11", base 18" x 11"

Both images courtesy of the Artist, Harrah's Reno, and the Stremmel Gallery, Reno, Nevada

Born and raised in a farming community in eastern Idaho, Dwight Davidson was naturally influenced by a rural lifestyle. He grew up in an environment bountiful in domestic and wild animals, which provided him with a rich array of subjects for his considerable sculpting talent. Davidson was schooled in a variety of artistic media at the University of Utah-Salt Lake City and also studied ancient and contemporary sculpture and architectural ceramics in Paris. Davidson combines a keen sense of humor with sensitivity for his surroundings to produce his tongue-in-cheek sculptures.

The animal gamblers in Davidson's sculptures are every bit as infatuated as their human counterparts with their chosen casino diversions. The cows are "loaded up" on number 20 "straight-up"; it pays 35-1. The frogs seek an even bigger payday; the elusive slot jackpot has the potential to return thousands for a bet of less than a dollar. A slang term for an illegal gambling house is "steer joint." A Mexican gambling game that is an offshoot of *skat* is called frog.

NUMBER TWENTY OR WE'RE BACK TO THE PASTURE, Dwight Davidson

LUCKY DRAGONFLY, Dwight Davidson

THE CARD PLAYERS

1996

Fernando Botero

Born: 1932, Medellin, Colombia

oil on canvas, 118 cm x 154 cm

© Fernando Botero, Courtesy of Marlborough Gallery, New York

Fernando Botero, a celebrated artist from Colombia, South America, was contributing drawings and illustrations to local newspapers as early as age 16. He studied in Spain, Italy, and Paris, where he spent many summer vacations. Botero's early stylistic influences came from Orozco and Picasso, but as his work matured, Botero developed his own style, in which all of his subjects are portrayed as oversized—"fat people in humorous poses," as they've been described by disparaging critics.

Botero's interest in card games is established by a number of his paintings and drawings. Given that the woman here is sitting on cards removed from the deck, the focus of this piece appears to be impropriety or cheating. Three-player games popular in South America are *hombre* and Spanish solo.

THE CARD PLAYERS, Fernando Botero

PORTRAIT OF CHESS PLAYERS

1911

Marcel Duchamp

Born: 1887, Normandy, France Died: 1968

oil on canvas, 40" x 40"

Philadelphia Museum of Art, Louise and Walter Arensberg Collection
© 1999 Artists Rights Society (ARS), New York/ADAGF, Paris/Estate of Marcel Duchamp

At the beginning of his career, Marcel Duchamp was dedicated to Dada artistic principles, but later became associated with the Surrealist movement. Marcel joined his brothers—Jacques Villon and Raymond Duchamp-Villon, successful artists in their own right—in Paris, where he studied art at the Académie Julian. During that time, he dabbled briefly as a cartoonist. Strongly influenced by Cézanne and the Cubist movement, Duchamp moved to New York in 1915 where he became a U.S. citizen and spent the rest of his life. Along with his associates, Picabia and Man Ray, Duchamp founded the New York Dada group.

The fact that the effect of luck is nearly non-existent in chess has not dissuaded players from gambling on the game. Speed-chess matches in city parks have been known to be played for stakes, albeit low ones. Of course, a chessboard was the battlefield for one of the highest-stakes games of all time. In the 1997 pitting of man versus machine, the unfathomably sophisticated RS/6000 SP-based IBM supercomputer, Deep Blue, avenged countless inanimate predecessors that had succumbed to human chess (and poker) champions by defeating the greatest chess mind of all time, Garry Kasparov. Deep Blue won the dramatic final game of a six-game series to prevail: 3 1/2 points to 2 1/2 points.

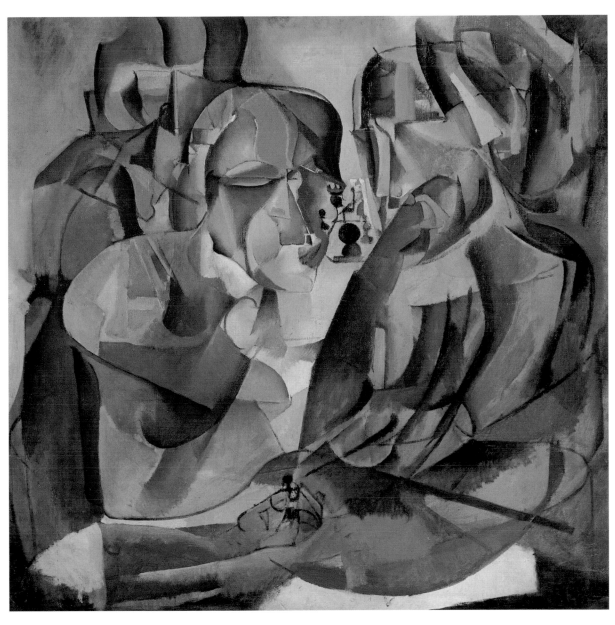

PORTRAIT OF CHESS PLAYERS, Marcel Duchamp

THE CARD PLAYERS
1660
Jan Steen
Born: 1626, Leiden, Holland Died: 1679

panel, 17 7/8" x 23 7/8"

Private Collection © 1999 Artists Rights Society (ARS), New York/Beeldrecht-Amsterdam

For biographical information about Jan Steen, see page 30.

This curious scene seems to depict a cheating maneuver, which, given the card on the floor, possibly went awry. The game is indistinguishable, though it could be an early version of all fours, a two-player game of possible Dutch origin that enjoyed great popularity in England. All fours was a predecessor of the American pitch (or auction pitch) and setback, games that are often played for money.

PIGS PLAYING CARDS
c. 1910
Artist unknown
Whereabouts of work unknown

Little information is available about this rendering of "Pigs Playing Cards," presumably inspired by the famous paintings of dogs playing poker (see Coolidge's "A Friend in Need," page 229). The visible hand appears to be four-of-a-kind, an excellent hand in poker, of course, but also the winning hand in a children's game called pig, which is thought to be a precursor of rummy.

THE CARD PLAYERS, Jan Steen

PIGS PLAYING CARDS, Unknown

POKER FACE

1989

Robin Morris

Born: 1953, New York, New York, USA

acrylic on canvas, 24" x 36"

Courtesy of the Artist, Coral Gables, Florida

Robin Morris was born in New York City and studied art at Syracuse University and C.W. Post College. Her style is often described as a combination of Cubism, Art Deco, and contemporary. A versatile artist, Morris also creates ceramics, as well as works from bronze, textiles, and paper. She made her mark on the New York art scene with her critically acclaimed lithograph "The Couple"; "Poker Face," which adorned the cover of the October 4, 1991, *Card Player* magazine, was Morris' first incursion into gambling art.

A powerful skill possessed by great poker players is the ability to pick up "tells" from competitors. A tell is an involuntary, and often extremely subtle, movement or expression that imparts information about a player's hand. Maintaining a "poker face" reduces the chances of a tell being conveyed—for example, did this player complete his royal flush?

POKER FACE, Robin Morris

HEARTS ARE TRUMPS

1872

Sir John Everett Millais

Born: 1829, Southampton, England Died: 1896

oil on canvas, 165.7 cm x 219.7 cm

© Tate Gallery, London, England/Art Resource, New York, New York

Sir John Everett Millais was groomed from early childhood to be an artist. Though Millais was one of the leading illustrators for wood-engraved magazines and books, which were popular in the 1850s, he was primarily a painter for most of his career. He most enjoyed painting images of handsome happy children, and he often used his own children and grandchildren as models. Millais was the first painter in England to be granted the title of baronet.

Given the date that "Hearts Are Trumps" was painted, the game portrayed is likely dummy whist, a form of the game developed to accommodate shorthanded play. The gambling game of knockout whist is thought to be a direct descendant.

HEARTS ARE TRUMPS, Sir John Everett Millais

CASINO

1956

Joan Mitchell

Born: 1926, Chicago, Illinois, USA Died: 1992

oil on canvas, 69 3/4" x 68 1/4"

Private Collection © Estate of Joan Mitchell. Courtesy of Robert Miller Gallery

Born of aesthetically talented parents (her father was an actor and her mother was a poet), Joan Mitchell became a successful Abstract Expressionist early in her career. While studying at the Art Institute of Chicago, Mitchell was influenced by Cézanne and the Cubist movement. She eventually settled in France, where she lived in Vetheuil, famous throughout the art world as the village where Claude Monet once lived and created some of his famous Impressionist paintings.

Mitchell's interpretation of a casino is certainly based on the atmosphere encountered in American gambling houses. Whereas European casinos are quiet and sedate, American casinos attempt to disarm gamblers by bombarding them with an array of stimuli—such as noise, color, and frenetic activity—designed to induce a state of reckless euphoria.

CASINO, Joan Mitchell

THE CARD PLAYERS

1882

Rufus Wright

Born: 1832 Died: Date unknown

oil on canvas

The Oakland Museum, Kahn Collection

A fair number of 19th-century Eastern painters struck artistic gold during the California Gold Rush, and Rufus Wright, a successful Washington, D.C. portrait painter, was one of them. Wright arrived in California around 1857 and contributed to the artistic portrayal of the period.

Wright's "The Card Players" was one of many representations of the miners' favorite form of entertainment. His depiction of a Chinese coolie cleaning out three Caucasian players during a game of poker parallels a Bret Harte poem of the time in which Anglo gamblers go after a "heathen Chinee" after he's beaten them at cards. The man with the knife has just had his four kings (on the floor) "cracked" by four aces—an agonizing occurrence universally known to poker players as a "bad beat."

THE CARD PLAYERS, Rufus Wright

STAG AT SHARKEY'S
1909
George Bellows
Born: 1882 Died: 1925
oil on canvas, 92 cm x 122.6 cm
The Cleveland Museum of Art, 1999, Hinman B. Hurlbut Collection

Though renowned for his depiction of prize-fighting scenes, George Bellows was also an accomplished lithographer, etcher, and painter of landscapes and New York genre scenes. Bellows' earliest boxing portrayals, such as "Stag at Sharkey's," demonstrated what some art critics described as "rapid slashing brush strokes," the very elements that also make for a good boxing match. Early in his career, Bellows experienced considerable derision from art-world academics who criticized his combatants for resembling the caricatures of Daumier and Goya. Also because his work often portrayed life in the bars and alleys and on the docks of New York, the style was contemptuously labeled the "Ashcan School." Over the years, however, as the popularity of prize-fighting increased, Bellows became revered as the world's pre-eminent painter of boxing scenes.

Despite being illegal everywhere in the United States except the sports books of Nevada, betting on sporting events is one of the most common forms of gambling today. The biggest betting events are the Super Bowl, the World Series, the NCAA basketball Final Four, and championship boxing matches. In both of these images, it's a given that the majority of the spectators have made a wager of some type. In the days of club fights, as depicted in "The Stag at Sharkey's," bets were placed with roving bookies, or simply "man-to-man" between members of the crowd.

INTRODUCTION OF CHAMPIONS AT MADISON SQUARE GARDEN
1964
LeRoy Neiman
Born: 1927, St. Paul, Minnesota, USA
oil on canvas, 72" x 118"
Collection of Madison Square Garden

For biographical information about LeRoy Neiman, see page 24.

The big fights of today rarely take place outside of the betting meccas of Las Vegas or Atlantic City, where they're staged with much pomp and circumstance. Neiman's image, though set in New York City, is representative of the spectacle, with ringside seats occupied by politicians, gangsters, show people, and beautiful women. Near the top right edge of "Introduction of Champions at Madison Square Garden," soon-to-be-champion Muhammad Ali (Cassius Clay at the time) is shown standing and shaking his fist.

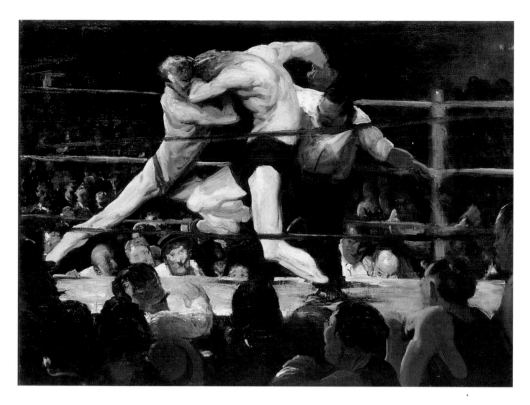

STAG AT SHARKEY'S, George Bellows

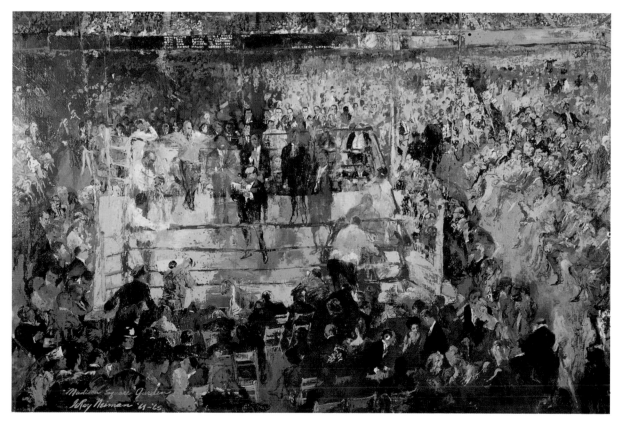

INTRODUCTION OF CHAMPIONS AT MADISON SQUARE GARDEN, LeRoy Neiman

THE FALSE START
1864
Edgar Degas
Born: 1834, Paris, France Died: 1917
oil on panel, 12 5/8" x 15 3/4"
Yale University Art Gallery, John Hay Whitney (B.A. 1926, Honorary M.A. 1956) Collection

Although considered an important participant in the French Impressionist movement, Edgar Degas began by studying the Italian masters. Upon returning to Paris from Italy, he met and befriended Eduard Manet. Together, they adopted the Impressionistic painting style. Manet was also responsible for inspiring Degas' fascination with the body movement of ballet dancers, which occupied the latter stages of his artistic career when his sight was failing. After exhausting his study of ballet dancers, Degas turned to another form of movement that fascinated him: horse racing. "The False Start" is one of his most popular paintings of the racehorse genre.

Evidence suggests that horse racing, referred to as the "Sport of Kings," dates back as far as 6,000 years.

Records of organized racing can be traced back to late 12th-century England. For most of the sport's existence, betting on horses was conducted via a succession of low-tech methods, including man-to-man wagering, auction pools, and independent bookmakers. All of these methods were likely in effect at the 1864 meet that Degas portrays here. Only one year later, the pari-mutuel system was developed by Pierre Oller in Paris (the name "pari-mutuel" probably comes from a loose translation that means "betting among ourselves," rather than from the city of origin). The pari-mutuel, in which odds are determined based on the money bet on each entrant, revolutionized race wagering and is now used throughout the world for betting on horses, dogs, and jai alai.

ASCOT FINISH
1973
LeRoy Neiman
Born: 1927, St. Paul, Minnesota, USA
oil on canvas, 48" x 72"
Private collection

For biographical information about LeRoy Neiman, see page 24.

Temporarily ignoring that LeRoy Neiman's "Ascot Finish" takes place in England, where bookmak-

ers coexist with pari-mutuels, the cheering crowds at today's racetracks are sure to have eyes glued to the big "totalizator" board, which constantly updates horse odds to reflect the public's betting sentiment.

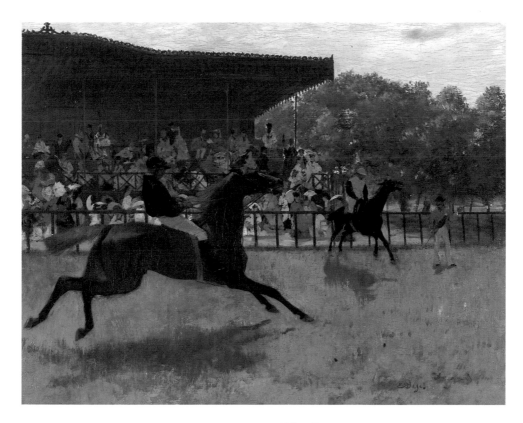

THE FALSE START, Edgar Degas

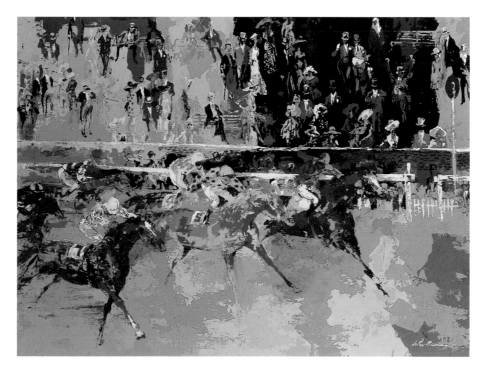

ASCOT FINISH, LeRoy Neiman

A FRIEND IN NEED

c. 1870

Cassius Marcellus Coolidge

Born: 1844, Philadelphia, New York, USA Died: 1934

Whereabouts of work unknown

Without question, the most recognized gambling paintings ever created are the various renderings of dogs playing poker by C.M. Coolidge. In fact, surveys have shown these paintings to be among the most recognizable artwork of any type. Coolidge was born in upstate New York and began his career as a druggist and a painter of house numbers and street signs. He also founded a small-town newspaper called the *Antwerp News.* Coolidge was already known for his paintings of dogs playing cards before he was approached by the publishers Brown & Bigelow. The company hired him to create calendars and other advertising products. Coolidge is credited with producing 16 paintings of dogs—most of them playing cards—while in the employ of Brown & Bigelow.

Of all of Coolidge's dog paintings, "A Friend in Need" is his most famous. Replicas have adorned the walls of basements, bathrooms, and pool rooms across America for a century. The scene has a surprisingly modern look to it, which may account for its timelessness; only the cards, minus corner "indices," betray the period. Once again, cheating is a focal point. The game, without question, is five-card draw.

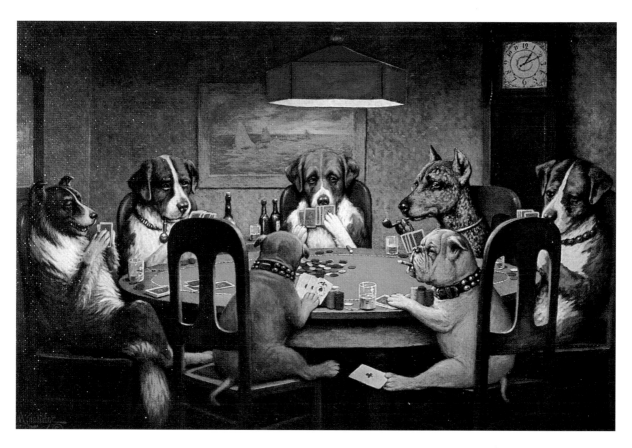

A FRIEND IN NEED, Cassius Marcellus Coolidge

NEW YORK STOCK EXCHANGE

1971

LeRoy Neiman

Born: 1927, St. Paul, Minnesota, USA

mixed media on paper, 26" x 40"

Collection of the Artist

For biographical information about LeRoy Neiman, see page 24.

The granddaddy of all gambling pits is located on Wall Street in New York City. While there is a marked difference between prudent investment in the equity issues of fundamentally solid companies and throwing dice on a crap table, trading in hedging instruments known as "derivatives" (futures and options), especially for purposes of pure speculation, is less far removed from casino gambling. The traders on the floor rank among the fastest and loosest gamblers in the world—which is always more easily done when playing with other people's money.

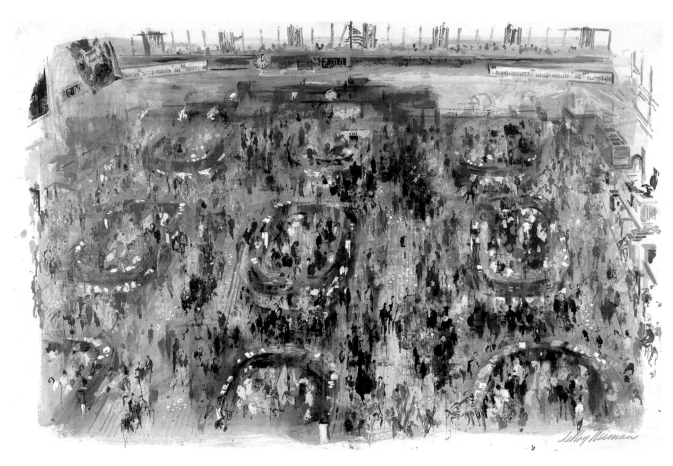

NEW YORK STOCK EXCHANGE, LeRoy Neiman

Index of Artists

How To Contact Living Artists

Living artists represented by museums or commercial galleries can be contacted through those establishments. For living artists not currently associated with any institution, contact information is listed below.

Brna, Suz
Phone: (702) 259-7677
Fax: (702) 259-7677
E-mail: SC BRNA@netzero.net
Web site: http://contemporary.artscollective.org/members/brna-s

Goodfellow, Stephen
Web site: http://www.goodfelloweb.com

Greene, Lorna
7648 Rolling View Dr. Ste. 201B, Las Vegas, NV 89129
Phone: (702) 656-7447
Fax: (702) 656-7447

Kriegstein, Zara
1717 Agua Fria, Santa Fe, NM 87501
Phone: (505) 986-0116
Fax: (505) 986-0116

Morris, Robin
New Decco, Inc. (800) 543-3326

O'Lear, Ann
P.O. Box 9122, Reno, NV 89507
Phone: (775) 348-2655

Speer, Steve
E-mail: speer@interport.net

Photo Credits

The authors would like to thank the following photographers and institutions for contributing photographs of images to *The Art of Gambling Through The Ages.* (Page numbers for these photographs are listed after the contributor's name.)

Photographers

Bodycomb, Michael 5, 73
Clements, Geoffrey 3
Cox, Jason 35, 103, 105, 107, 119, 151, 161, 169, 179, 185, 229
Evans, Arthur 125
Fatherree, M. Lee 223
Lessing, Erich 9, 93, 181, 189
Sanders, Larry 177
Smith, Craig 83
Stallsworth, Lee 65
Wartell, Bob 41, 105

Institutions

Aca Galleries, New York 205
The Art Institute of Chicago 187
The Detroit Institute of Arts 111
Kennedy Galleries, New York 143
The Metropolitan Museum of Art, New York 113, 117
The Museum of Modern Art, New York 11, 29
RMN-Arnaudet 183

About Huntington Press

Huntington Press is a specialty publisher of Las Vegas- and gambling-related books and periodicals. To receive a copy of the Huntington Press catalog, call 1-800-244-2224 or write to the address below.

Huntington Press
3687 South Procyon Avenue
Las Vegas, Nevada 89103